Tribute to
Teddy Bear Artists

Series 3

by Linda Mullins

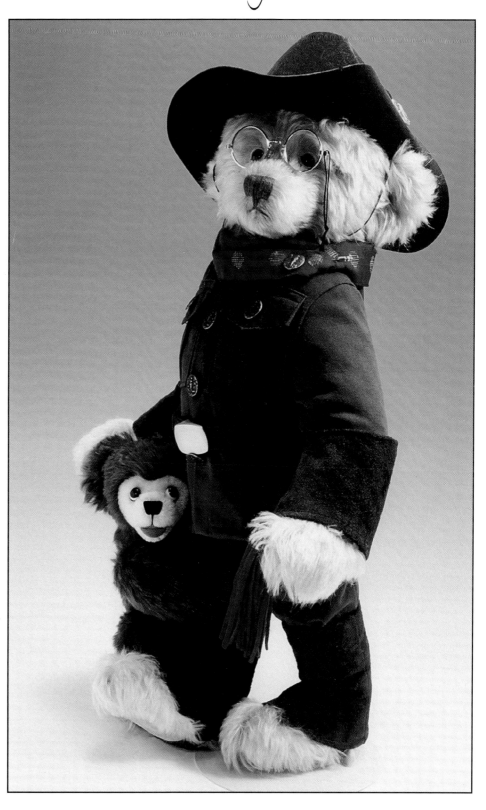

Published by

Hobby
House
Press
™

Hobby House Press, Inc.
Grantsville, MD 21536

Dedication

This book is affectionately dedicated to my wonderful brother, John Parris.

Acknowledgments

All the artists featured here deserve special recognition for their participation and generosity of spirit. I thank them for sharing their bear creations, stories and expertise with me for this publication. Their kind cooperation represents the very nature of networking in the bear world. In all my life I have never been exposed to the supportive climate which bear makers inspire among their colleagues. Without such a warm atmosphere this book would never have become a reality. Thanks also to my editor, Carolyn Cook for her advice and patience, and to Patricia Matthews for her excellent computer service. My deep appreciation to Tammy Blank for her tireless creativity in designing this book. My sincere appreciation goes also goes to my publisher, Gary Ruddell, for his ongoing support and faith in me. My heartfelt thanks as well go to my dear friend Georgi Bohrod Stookey. Her sincere personal interest and professional contribution continue to be greatly important to me. Finally, no words can ever express the gratitude I have for my husband Wally who never fails to give me the understanding I need and encouragement in all my endeavors.

Front Cover

Finishing Touches. 1997. Large bear (25in [64cm]) made by Jeannette Warner—Nette Bears, made of long sparse honey beige mohair; glass eyes and is fully jointed. Four little elves (4in [10cm]) and pincushion mouse are made by Janie Comito—Janie Bear. The elves festively colored outfits are an integral part of their jointed bodies. Created especially for the cover of this book, this piece was inspired by an antique Christmas card.

Back Cover

Time Machine Teddys and Time Machine Tinys. 1954-1997. By Beverly Matteson Port—Beverly Port Originals. 1-½in-28in (4cm-71cm). Bears are made from a variety of quality fabrics and represents a sample of the numerous creative and unique designs by this multi-media pioneer teddy bear artist.

Additional copies of this book may be purchased at $29.95 (plus postage and handling) from

Hobby House Press, Inc.

1 Corporate Drive
Grantsville, MD 21536

1-800-554-1447

or from your favorite bookstore or dealer.

©1998 Linda Mullins

ISBN: 0-87588-526-8

Table of Contents

A glimpse at the world of teddy bear artists

American Teddy Bear Artists

Lately many people have asked me why I embarked on the third in this series of a *Tribute to Teddy Bear Artists*. Each time I have finished one of my numerous books, I always find myself wishing to say more. More about my love for teddy bears, more about my deep respect for the artists who create these wonderful objects, more about the importance of the teddy bear as a work of art, more about the impact teddy bears have on people from all walks of life. And so, the best way to express those emotions is to once again share with readers the beauty and individuality of teddy bear artists from around the world.

As the popularity of teddy bear collecting increases, so does that of teddy bear making. Many people just make teddy bears for a hobby. Others are so serious about their avocation that they begin to sell their creations and still others journey into the world of business with teddy bears at the hub.

As the years pass, pioneer teddy bear

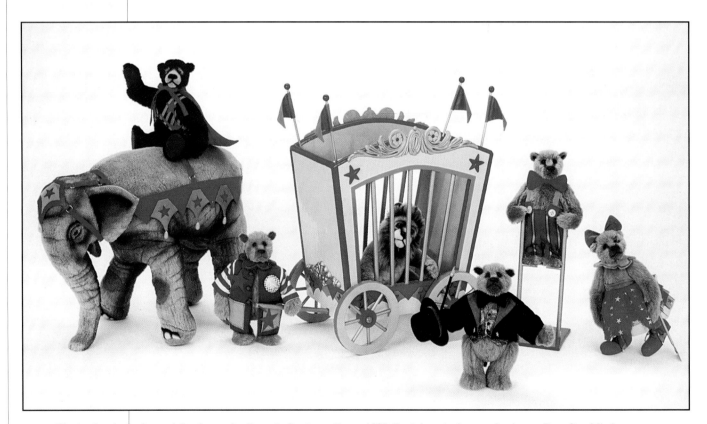

Illustration 1. *Ladies and Gentleman the Circus is Coming to Town.* 1997. By Arlene Anderson—Lexington Bear Co. 36in long x 18in high (91cm) x (46cm). Various colors of mohair, alpaca and German plush. All animals have glass eyes, are jointed and air brushed. The Circus Wagon was handmade by Arlene's husband Eric. Created for Walt Disney World's®'' 1997 One-of-a-kind Teddy Bear Auction. *Photography by Fritz Vontagen.*

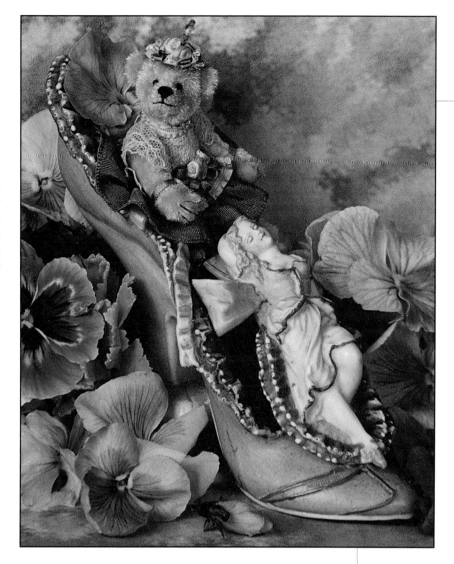

Illustration 2. *A Thing of Beauty Is A Joy Forever.* 1997. By Janie Comito—Janie Bear. Bear is 3in (8cm); beige upholstery fabric, black onyx eyes; fully jointed. Costume created from vintage fabrics and laces. *Photograph by George Comito.*

makers continue to present their finest work to the public. They set high standards to which newcomers must aspire. And, each crop of new artists seems to get better and better.

It is no secret how much I enjoy working with teddy bear artists. Many deep friendships and still more relationships built on admiration and respect have resulted from my close association with the teddy bear artist world. Whether I've grown to know them at my twice yearly show in San Diego, through writing and researching one of my books, fund raising for earthquake victims of Kobe, or my involvement with two fantastic museum projects in Japan, I am honored to

be connected with these wonderful people. It has been so heart warming and rewarding to see so many of them kick-off their careers and then go on to become noted as highly respected artists.

I am very grateful to the sample representation of *pioneer* teddy bear artists who consented to write brief overviews of the teddy bear scene in his or her particular country. You will see these overviews at the beginning of many of the chapters of this book. You will then discover that some countries are just beginning to be aware of the joys of teddy bear making and collecting. Others have a rich tradition in our furry friend.

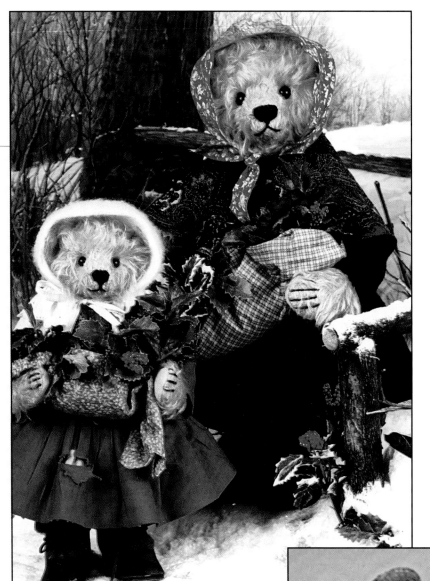

Among my main goals is to promote interest in the artist bear and to awaken the world to the fine, original and creative work of teddy bear artistry. One way of bringing the artist bear to the public is the teddy bear auction. Many of the photographic examples in this book were created for charitable fund-raisers. Not only does our beloved bear manage to bring in substantial amounts of money, but this generous energy seems to generate some of the most creative work of each participating artist. I invite you to see for yourself as you read this book and look at the wonderful pictures of our own good will ambassador: the teddy bear.

Illustration 3. *The Holly Gatherers, Sarah and Emily.* 1994. By Barbara Conley—Roley Bear Co. 10in (25cm) and 16in (41cm); honey gold mohair; shoe-button eyes; excelsior and polyester fiberfill stuffing; fully jointed (flex in arms). Clothes and display made entirely by artist. Inspired by English watercolorist Fredrick James' painting *The Holly Gatherers.* Created for Clarion's One-of-a-kind Teddy Bear Auction.

llustration 4. *How Does Your Garden Grow?* 1997. Corla Cubillas—Dancing Needle. Papa Beary (30in [76cm]) tends to his special flowers. His youngest helper (16in[41cm]) sits atop his shoulder. Papa's second helper (19in [48cm]) enthusiastically gives her support. Sprouting up through the flowering plants are three tiny 5in (13cm) teddies. Overseeing this venture is a 5in (13cm) mohair bunny hidden beneath the bench. Bears are made of imported mohair, German glass eyes; fully jointed with flexible armature for posing. Created for Walt Disney World's® One-of-a-kind Teddy Bear Auction.

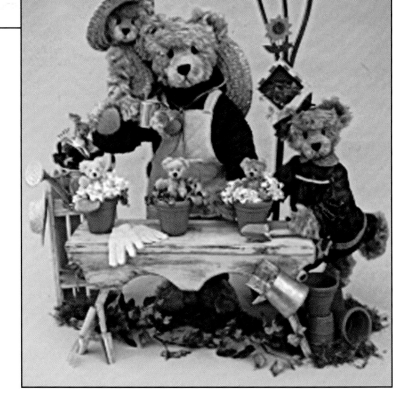

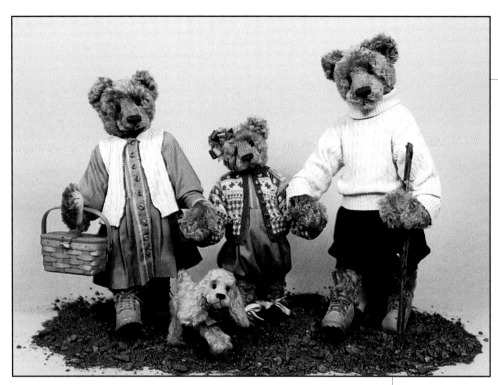

Illustration 5. *A Hiking We Will Go.* 1996. By Rosalie Frischmann—Mill Creek Creations. Dad is 32in (81cm); Mom is 28in (71cm); Little Katie is 22in (56cm); Puppy is 10in (25cm). All pieces are made of imported distressed mohair, black glass eyes; fully jointed; swivel tilt® heads and armatures encased in limbs for poseability. Casually dressed in country clothes ready for a walk in the woods. Created for Walt Disney World's® 1996 One-of-a-kind Teddy Bear Auction. Realized auction price $7,500.

Illustration 6. *School Days.* 1989. By Flore Emory—Flore Bears. 30in (76cm); beige synthetic fur; glass eyes; polyester fiberfill stuffing; fully jointed. Flore's nostalgic looking bears are an important part of her country home. Exemplifies how teddy bears can be incorporated into the interior decorating of one's home.

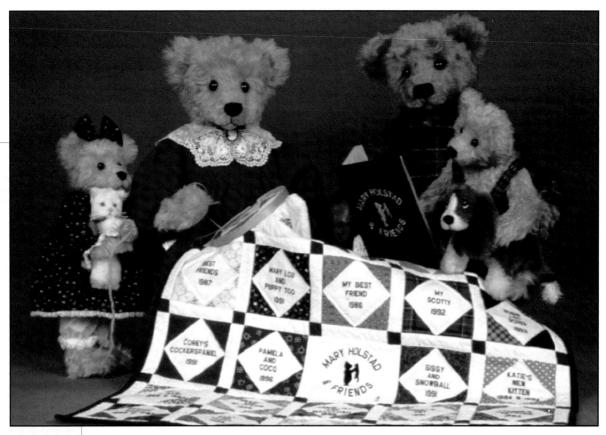

Illustration 7. *Four Bears Remember Their Forebears.* 1996. By Mary Holstad—Mary Holstad and Friends. Bears are 12in (31cm)-27in (69cm). All pieces are made of mohair, with glass eyes and fully jointed bodies. Mother works on a quilt made from all Mary's limited edition bear's clothing fabrics with their name and the date that they were first produced embroidered on each square. The center features Mary's logo. The concept is the history of Mary's limited edition bears. Produced for Walt Disney World's® 1996 One-of-a-kind Teddy Bear Auction. Realized auction price: $11,000.

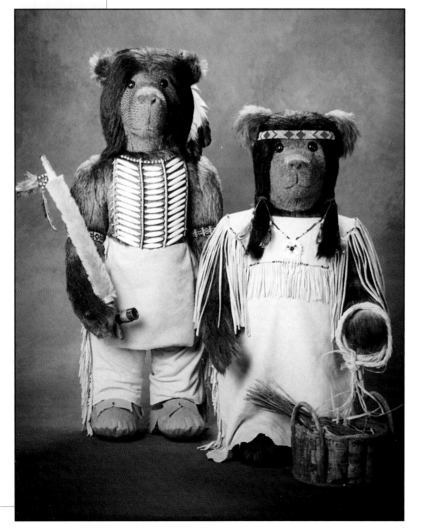

Illustration 8. *Tom Bigbee and Sabine.* 1994. By Joanne Mitchell—Family Tree Bears. (Left) *Tom.* 28in (71cm). (Right) *Sabine* 23in (58cm). Bears are made of two kinds of medium brown mohair; lead crystal eyes; needle sculpted suede nostrils; fully jointed. Bears named after the Tombigee River and the Sabine Pass between Texas and Louisiana. Created in the image and tradition of the Alabama-Coushatta Indian Tribe who reside in Polk County's Big Thicket, the bears wear clothing of lambswool, suede, beads, woven bracelets and feathers.

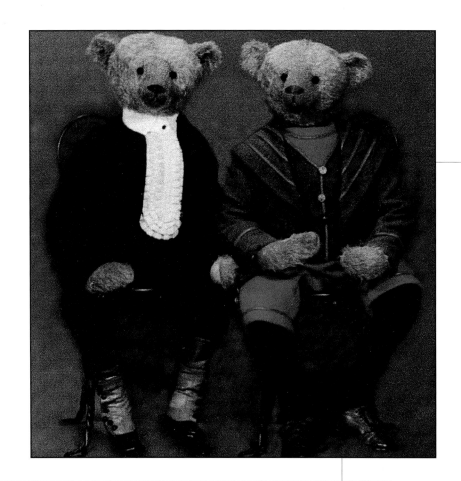

Illustration 9. Bears. 1998. By Steve Schutt — Bear "S"–ence. (Left) *Christopher.* (Right) *Eli.* 31in (79cm); rusty gold distressed mohair; German black glass eyes; head stuffed with excelsior, body stuffed with polyester fiberfill; fully jointed; elbows and knees permanently bent. Representing Steve's new "Vin-tique line." Antique style bears dressed using vintage items. *Photograph by Mueller Studios.*

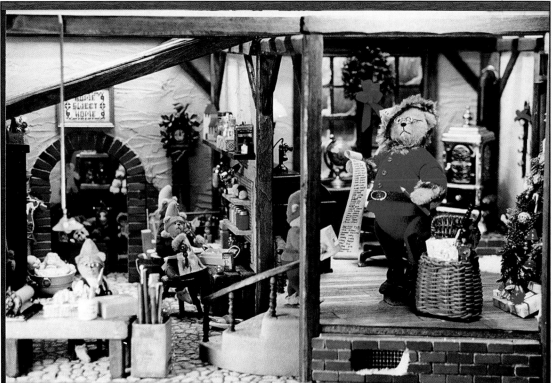

Illustration 10. *Santa's Workshop.* 1998. By Carol Stewart. Santa (6in [15cm]) is checking his list and packing his bag with presents for good and bad little bears (bad bears get C.O.D.). Five little elves (3in [8cm]) are busy helping Santa check stock, wrap gifts and put the final touches on the wooden toys and painted ornaments; a reindeer waits impatiently at the door. Santa Bear's pattern was inspired by Christmas drawing by Thomas Nast. Created for Walt Disney World's® 1998 One-of-a-kind Teddy Bear Auction.

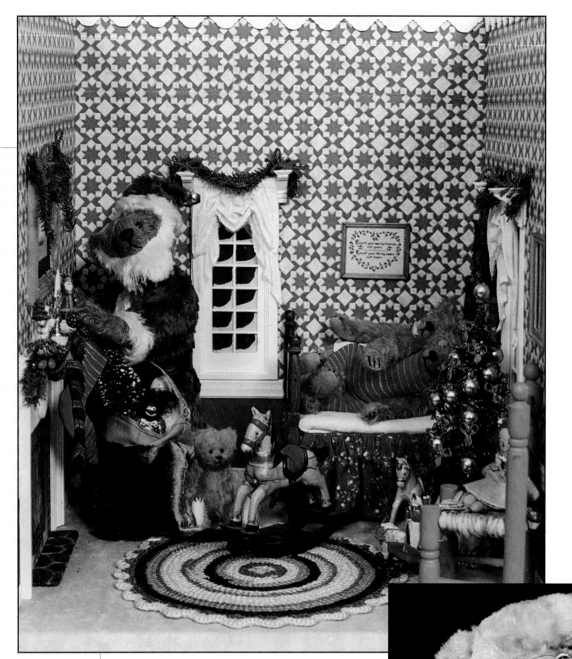

Illustration 11. *Christmas Eve.* 1998. By Kathleen Wallace—Stier Bears. Father Christmas: 11in (28cm). Two bear cubs: 7in (18cm). All bears are made of mohair and are fully jointed. This scene depicts that magical time celebrated throughout the world—the night before Christmas. Created for the Cuddly Brown Museum, Kobe, Japan.

Illustration 12. *Grandfather Roosevelt and Baby Edith.* 1997. By Beverly White—Happy Tymes. *Grandfather* (Theodore Roosevelt) is 30in (76cm); blended gray mohair, amber glass eyes; gray leather paw pads; polyester fiberfill stuffing, fully jointed with bolt and locknut joints and Lock-Line® armature in limbs, self standing. Dressed in a three-piece wool suit. *Edith* is 15in (38cm); off-white feather mohair, blue glass eyes; white doeskin paw pads; polyester fiberfill stuffing; fully jointed; flexlimb® extremities. Dressed in a pink wool coat and bonnet. This Portrait Bear® is recreated from an original photograph of Theodore Roosevelt affectionately holding his granddaughter Edith. Created for Huis Ten Bosch, Teddy Bear Kingdom, Nagasaki, Japan.

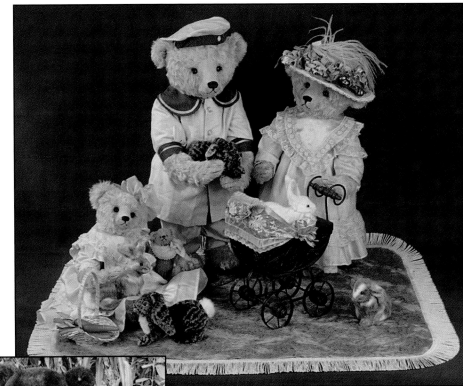

Illustration 13. *Some Bunny Loves Me.* 1998. By Joan and Mike Woessner—Bear Elegance Exclusives. Bears are 4in-20in (10cm-51cm); made of German mohair; glass eyes and fully jointed. Dressed in Victorian-style clothes. This endearing scene depicts the children's love of their pet rabbits. Created for Walt Disney World's® 1998 One-of-a-kind Teddy Bear Auction. *Photograph by Larry McDaniel.*

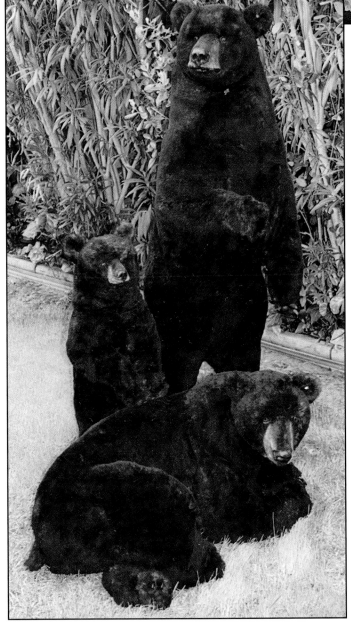

Illustration 14. The Black Bear Family. 1998. By Michael J. Woessner—Bear Elegance Exclusives. Papa is 64in (156cm). Mama is 52in (132cm). Cub is 36in (91cm). Black on brown alpaca mohair blend; glass eyes; unjointed head and body; hand-molded urethane rubber nose; nylon claws; hand-sculpted epoxy clay mouth; ultra suede paw pads. To achieve a realistic look, Michael studies photographs and videos of real bears. Created for the Cuddly Brown Museum, Kobe, Japan.

Illustration 15. (Back, left to right). *Bertie, Ming the Panda* and *Ralph.* (Front) *Baby Billees.* 1997-1998. By Jennifer Laing—Totally Bear. 5in-15in (13cm-38cm). Various types of German mohair; black glass eyes and black antique boot button eyes; wool felt and painted ultrasuede paw pads; polyester fiberfill stuffing, pellets and lead shot stuffing. Entirely hand-stitched and hand-painted shading and details. One-of-a-kind except for *Ming-the Panda* who is a limited edition of 10.

Illustration 16. *Nightwatch.* 1997. By Deb Canham—Artist Design Inc. Bear is 3-½in (9cm). Mouse is 1in (3cm). Created for ABC Schaumburg's 1997 One-of-a-kind Auction.

British Teddy Bear Artists

Illustration 17. *Motherhood.* 1998. By Jo Greeno. 22in (56cm); English straight and sparse mohair; black glass eyes; fully jointed. Mother has flex encased in limbs. Handmade and designed clothes of antique fabrics, silks and lace. An extension of the artist's family theme. Created for Huis Ten Bosch's Teddy Bear Kingdom's One-of-a-kind Auction.

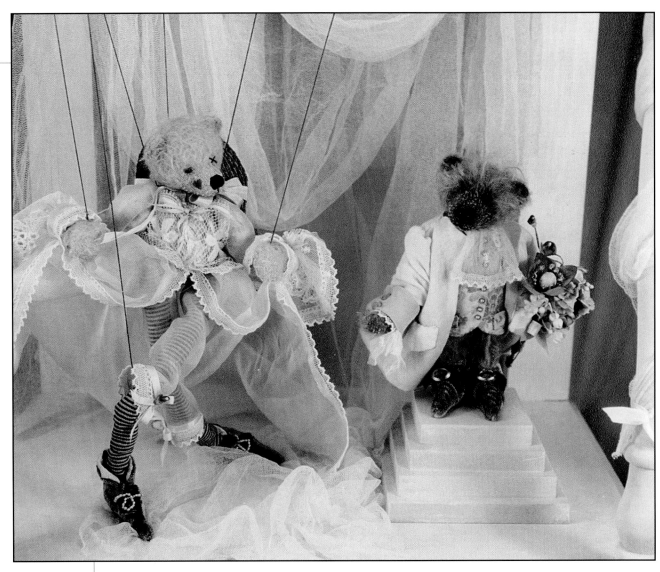

Illustration 18. *Marionette Theatre*. 1998. By Elaine Lonsdale—Companion Bears. *Marionette Bear* is 10in (25cm); mohair head and paws; cloth body; glass eyes; fully jointed. *Ludwig Bear* is 6in (15cm); old style mohair; glass eyes; leather nose; hand-dyed cotton coat; silk brocade waistcoat; velvet shoes. Winner of the 1998 British Bear Artist Award, Category Seven.

Illustration 19. *Come Join Us At The Ice Skating Party.* By Lyda Rijs-Gertenbach—Lyda's Bears. 3-½in (9cm)-10in (25cm). Two largest bears: beige and brown mohair; four smaller bears; gold, beige and brown mohair (hand-dyed); black glass eyes; reversed old cotton velour pads; sheepswool stuffing; fully jointed; hand-knitted clothes. Skating is a favorite recreation in the Netherlands. *Photograph by well-known teddy bear photographer Mirja de Vries.*

Dutch Teddy Bear Artists

Illustration 20. *Bavarian Family.* 1997. By Marie Robischon— Robin Der Bär, Creation Marie. Approximate sizes: 18in-12in (46cm-31cm). One-of-a-kind. Created for Huis Ten Bosch, Teddy Bear Kingdom, Nagasaki, Japan. Marie is renowned for creating bears in the classic style and materials—mohair, glass or antique shoe-button eyes, wooden wool stuffing with serious faces, long arms and large feet. Their extremely detailed clothes are often enhanced with antique accessories and made from antique materials. Specialty is dressing the bears in old military woolen outfits, rough linen or leather.

Illustration 21. *My Little Flower.* 1998. By Dagmar Strunk— Bärenhöhle. 14in (35cm); yellow gold sparse mohair; artist designed glass eyes with eyelids; open mouth; fully jointed; realistically hand-sculpted face, hands, feet and claws. Bear represents the brilliant yellows and warmth of the summer sun. Limited edition of three. Nominated in 1998 for the Best European Bear Artist.

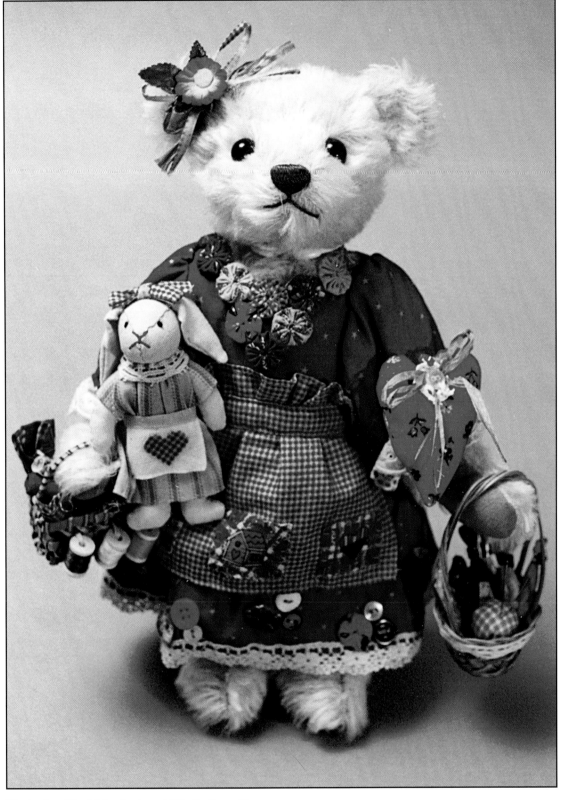

*Japanese
Teddy
Bear
Artists*

Illustration 22. *I Like Sewing.* 1997. By Ikuyo Kasuya—
Bruin Ikuyo Kasuya. Bear is 9-½in (24cm); distressed white
mohair; black glass eyes; suede paw pads; fully jointed.
Dressed in star print cotton dress with checkered patchwork
apron. Rabbit made of tea dyed cotton. *Photograph by Hideaki
Hayashi.*

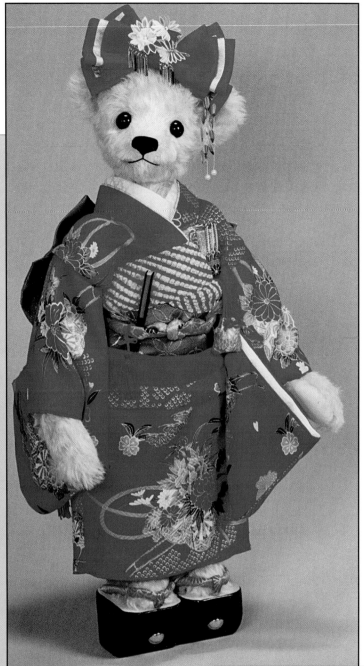

Illustration 23. *Sakura.* 1998. By Michi Takahashi — Fairy Chuckle®. 19in (48cm); light beige distressed swirly German mohair; black glass eyes; ultrasuede paw pads; polyester fiberfill stuffing; fully jointed (armature in arms). Dressed in authentic Japanese national costume. Completely handstitched. Representing a seven year old Japanese girl. *Sakura* means "Cherry Blossom" in Japanese.

Illustration 24. *Okuizome.* (The Ceremony of Giving First Food to a Baby). 1997. By Terumi Yoshikawa — Biscuit Entertainment Corporation, Rose Bear®. Bears are 16in (41cm)-8in (20cm). English mohair; plastic eyes; cotton and pellet stuffing; fully jointed. Kimonos and Obis made from old Kimonos. Representing traditional Japanese ceremony.

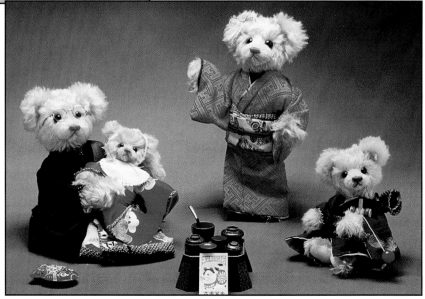

American Teddy Bear Artists

Steve Schutt:

A pioneer artist looks at the teddy bear scene in America.

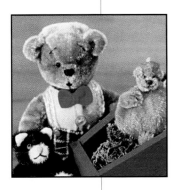

In America, Beverly Matteson Port's early interests and artistic achievements became the genesis of an infant handmade bear industry. Her influence became the catalyst that continues to produce new bear makers and advances in our industry. Carol-Lynn Rössel Waugh coined the term "Artist Bear" and wrote the first book on the subject. Barbara Wolter's Minnesota-based Teddy Tribune Convention (America s first) opened many doors for fledgling bear artists. Rowbear Lowman's American Teddy Bear Artist Guild (ATBAG) organization and conventions became the major educational force bringing artists, suppliers, shop owners, and the press together. Our industry continued to grow with the opening of new bear stores, the introduction of magazines, scores of new books on the subject, the production of more bear shows, new museums, and eventually even major corporations promoted the industry.

Early artists became known by winning convention contests. With the onset of teddy bear books, getting published became the major validator. Specific teddy bear retail stores became recognized for their selection of outstanding artist bears. Having product on their shelves was a stamp of approval. With coveted cover shots, feature stories with photographs, specific articles showcasing the creative abilities of individual artists, yearly contests and advertising space for purchase, the bear magazines offered another avenue of recognition. Later, as major corporations sponsored events, their inclusion of a teddy bear artist created yet another form of validation.

Today's American artist teddy bear market is full of character bears, vintage-inspired creations, the avant-garde bears and just plain teds. They range in size from tiny to gigantic; at times they are unadorned and at others elaborately clothed or decorated. Some artist's bears realistically portray the animal, others have necks and lengthened arms and legs with bent knees and elbows giving more human characteristics, while still others follow the traditional body formats created by toy makers earlier this century. In addition, artists offer an array of other animals, gollywogs, cloth dolls and even Santas.

I was lucky to enter the artist teddy bear industry at a time that allowed me and the business to grow-up together. Because my bears were far less expensive and my profit margin smaller back then, I, and others like me, offered a beginning-collector price point product. The high-end price tags were on the bears of those artists who came before us and who had made their mark. My lower prices offered me a ready market which allowed me to continue producing and to grow. As other artists of my generation and I grew and developed, so did the taste of collectors. Today, these collectors are sophisticated buyers who demand value, quality, and artistry. Artists entering the field today do not have the luxury of time to grow and perfect their skills.

The myth that all 12in (31cm) mohair bears should be valued at the same amount does not include other factors. The look of the bear and its face are probably the major considerations collectors consider. However, the artist's style, quality, construc-

tion skills and reputation also add to the collector's perceived value. The price of construction fabrics is only one factor. More new artists offering quality, beginning-collector market-entry priced pieces could provide a new wave of collectors for the industry while offering these new artists a ready market.

In an industry where artists strive constantly to produce the "perfect" bear for their personal needs and hopefully for the collector: fads, technical gimmicks and the latest fabrics are offered to entice collectors to open their wallet. A variety of collectors and their needs brings promise for our industry's future. Whether drawn by the thrill of the hunt, the touch of the heartstring, the fulfillment of an aesthetic ideal, a glimpse of the artist in the bear's features/persona, an attempt to fill a void in their life, or hope of financial profit, each collector brings their own agenda to the marketplace. Even though mass marketing can produce new trends, large companies can influence and validate new ideas, and wave after wave of new artists will enter the market place, it is, in the end, the collectors who must and will decide for themselves. Their varied needs make room for everyone and promise continued change and growth ahead.

Catherine Arlin
threads and...
Hayward, CA

Fifteen years ago I created a teddy for my infant son and found other people wanted to buy them, too. Although I create bears as large as 14in (36cm), my heart is in making miniature bears. This allows me to be creative on a constant basis. I also love to create scenes with my miniature bears. Color and texture are very important to me. Primarily I use mohair, upholstery velvet and stuff with polyester fiberfill. Each bear is produced on a limited basis and each has an individual twist. All of them are tagged with a tiny apple shaped plastic tag stitched in the back of the bear. Although I only attend a couple of shows a year, I have received awards such as First Place and Best of Show. In 1997 I was proud to be invited to participate as an artist at Walt Disney World's Teddy Bear and Doll Convention. Most of my orders come through word of mouth and limited wholesale accounts. Sometimes you'll see one of my ads in a magazine, and I'm currently working on a web page. I love capturing the heart and soul of a large bear in a tiny body.

Began selling retail: 1984
Price range: $150 (2in/5cm) -$400 (14in/36cm)
Approximate annual production: 200-250
Approximate number of shows per year: 2

Illustration 25. Catherine Arlin.

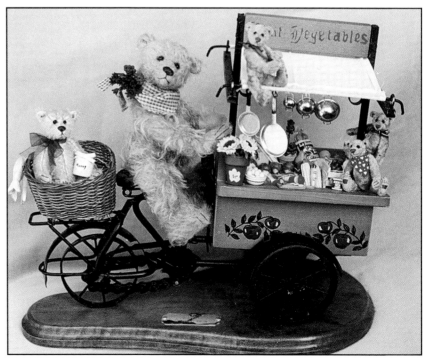

Illustration 26. *To Market We Go.* 1997. 2-½in-7in (6cm-18cm); larger bears made of mohair, smallest bear made of upholstery velvet; glass bead eyes; fully jointed. Created for Walt Disney World's® 1997 One-of-a-kind Teddy Bear Auction.

Teresa M. Bonenfant
T-Bone Bears
Bristol, CT

My mother knew I sewed well and had natural artistic ability. She is a teddy bear collector and encouraged me to get into this business in 1986. Today she is one of my best customers. My favorite creations are fantasy bears, but I have also designed many other types. Most are fully jointed mohair bears, but I also use ultra-suede, wool, cotton, acrylic, old army blankets and burlap. Probably my "Bragons" are the most popular design and the way my bears noses are stuffed is recognizable as well. Most of my bears are sold in New England and the East Coast.

Began selling retail: 1986
Price range:$46 (3in/8cm) -$265 (36in/91cm)
Approximate annual production: 300
Approximate number of shows per year: 8-10

Illustration 27. Teresa Bonenfant.

Rosalind Chang
Roz Bears
San Bruno, CA

My love affair with bear making began with a wedding. In 1984 a friend asked me to make a bride and groom bear couple for her wedding cake. These two 5in (13cm) bears started it all. These whimsical lit-tle creatures are made of upholstery materials, mohair, ultrasuede and wear cotton outfits. Sometimes they are "garnished" with rhinestones, beads and silk ribbon embroidery. They're stuffed with cotton batting. In 1990 I was honored with the Golden Teddy Award. However, my bear making is a second job. I am a full time public librarian and my bear making is limited. Over the years I've learned to take care of myself while at work. I use a craft glove (such as Handeze) reli-giously. I also make sure to give myself lots of sewing breaks. I love odd and slightly naughty bears and some-times I like to think that mine wake up at night and run around the house getting into mischief. I look forward to trying out more designs that are fun to look at and practical (e.g., a purse), so that collectors can use them and enjoy them even more.

Began selling retail: 1985
Price range:$15 (7/8in/2cm) - $175 (4in/10cm)
Approximate annual production: 25-50
Approximate number of shows per year: 1

Illustration 28. Rosalind Chang.

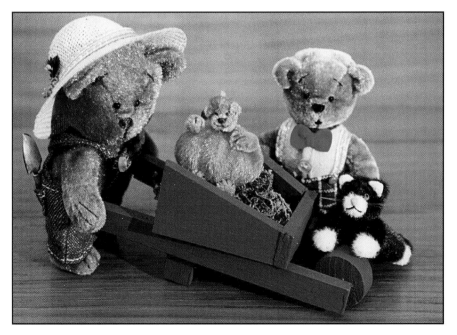

Illustration 29. (Left to right) *Mr. Blue Jeans.* 1997. 3in (8cm); tan upholstery fabric; black bead eyes; thread jointed. *Pumpkin Bear.* 1995. 1-1/8in (3cm); tan upholstery fabric head, arms and legs and orange upholstery fabric body; black bead eyes; stationary arms and legs, swivel head. *Mr. Sam.* 1997. 2-½in (6cm); tan upholstery fabric; black bead eyes; thread jointed. *Black Cat.* 1995. 7/8in high x 1-½ in long (2cm x 4cm); black and white upholstery fabric; Fimo® nose and eyes; unjointed wired body; swivel head. *Photograph by M. Quan.*

Alan Clark, Judy Davis & Steve Orique
Out of the Woods Originals
Modesto, CA

Since there are three of us who work as one, we have managed to develop a method which produces a considerable amount of bears and animals a year. We work mostly in open editions with some one-of-a-kinds. We constantly change, working in different furs and creating new patterns. We will come up with a concept, make that bear for a few months, then get excited about a new pattern. We are always going further.

First we come up with a concept. Steve draws out the sketch, then we all make the changes we feel are necessary. Alan orders all the supplies. He can always visualize a finished bear in a particular fur. Then he does the tracing and most of the cutting. Judy helps him out sometimes. (Alan quit his job last year to work on bears full time. Judy and Steve still work full time at their other jobs). Judy sews the bears. Then, Alan and Steve joint and pick seams. Alan also does the stuffing. Steve does the sculpting and places the eyes and ears. Judy does the noses and claws. Finally, Alan does the face trimming.

Our most popular designs are the tall skinny bears, opossums, and standing rabbits. Our distinct hallmark is the nose which is unique to our many animals.

Began selling retail: 1994
Price range:$110 (3-½ in/ 9cm)-$375 (28in/72cm)
Approximate annual production: 300
Approximate number of shows per year: 15

Illustration 30. (Left to right) Alan Clark, Judy Davis, and Steve Orique.

Illustration 31. (Left) *Little Bumble.* 1997. 14in (36cm); gold sparse curly mohair; German glass eyes; pink stitched nose; fully jointed. (Right) *Bumble.* 1997. 17in (43cm); straight gold mohair; German glass eyes; red stitched nose; fully jointed.

Sharon Coen
Country Bear Express
Apache Junction, AZ

I began making bears in 1979. I had an antique shop and made two 6 ft (182cm) bears and dressed them in old men's suits for display in the shop. The very first week they were on display I had orders for three sets. Most of my bears are one-of-a-kind, but I also do some limited editions. At first I sold my bears at antique shows and sold to a few antique shops. I didn't even know there were teddy bear shows for several years. I make fully-jointed mohair collector bears; those with bent legs are dressed in vintage clothing and my free standing ones are covered in mohair or vintage fabrics.

Began selling retail: 1979
Price range:$45 (6in/15cm) - $1,200 (72in/182cm)
Approximate annual production: 200
Approximate number of shows per year: 8-10

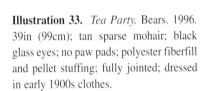

Illustration 32. Sharon Coen.

Illustration 33. *Tea Party.* Bears. 1996. 39in (99cm); tan sparse mohair; black glass eyes; no paw pads; polyester fiberfill and pellet stuffing; fully jointed; dressed in early 1900s clothes.

Billie Cudney
The Beary Patch
Cashmere, WA

I began to make bears in 1982 and seven years later began to sell them commercially. I work alone, using mohair, rayon, old coats, wool, acrylics and stuff with Fairfield polyfil and recycled plastic pellets to make 10-12 different designs in both large and small versions. You can tell they're my classic fully jointed bears and Rag bears by the rueful appearance on their face. I also use a great deal of vintage chenille and quilted jackets.

Began selling retail: 1989
Price range:$65(11in/28cm) - $225 (38in/96cm)
Approximate annual production: 250-300
Approximate number of shows per year: 6-8

Illustration 34. Billie Cudney. *Photograph by Terry Lass.*

Illustration 35. *Phoebe.* 1997. 38in (96cm); rust with dark backing mohair; German glass eyes; polyester fiberfill and plastic pellet stuffing; fully jointed with locking nuts and bolts; vintage chenille jacket with old fashioned sundress. *Photograph by Terry Lass.*

Mary Daub
Mary's Secret Garden
Newport, DE

I made my first bear at the request of Franklin Mint when I was showing an assortment of domestic animals at the New York International Toy Fair. I had wanted to create a grizzly cub for a couple of years.

Illustration 36. Mary Daub.

Three weeks later, I had my first bear, "Bubby." From that prototype came the style for which I've become known. Today I need the assistance of two full-time professional sewers, two part time sewers and one part time assembler. I continue to design all pieces from pattern to materials used, maintain all business communications, take orders, do shows, and create my newsletter *Secrets from the Garden*. Facial detailing and all finishing touches are still reserved for me.

The floral key sewn on the neck tells the buyer that this is a Mary Daub bear. My most popular designs are usually realistic, acrylic or mohair bears. They have expressive, realistic faces and incredibly poseable and huggable bodies. They feature taxidermy glass eyes set in leather lined eye pockets, open leather mouth with needle-sculpted lips, inset sculpted rubber noses, cupped ears, claws, stuffed leather toe pads with trapunto leather soles and authentic body shaping, including tails. I also have a more fanciful line of colorful mohair and alpaca bears. Loc-line skeletons allow enormous flexibility and playful posing. Many bears can stand on "all fours," sit, lay down, cuddle, cross their arms, and play "peek-a-boo."

Began selling retail: 1995
Price range:$140 (17in/43cm) -
$2,000-$3,000 (84in/213cm)
Approximate annual production: 500
Approximate number of shows per year: 6-8

Illustration 37. *Shadow Scout.* 1997. 24in (61cm); black tipped chocolate synthetic plush; glass taxidermy eyes set in leather lined eye sockets; individual padded toes, quilted and stuffed leather soles; shaved and air brushed face; completely poseable; sculpted rubber nose. *Photograph by John Mulliken/Unique Images.*

27

Kelly Dauterman
Kelly & Company
Colorado Springs, CO

In the last 15 years of making bears I have won numerous awards. However my greatest achievements are the charitable contributions I've made. I made a large limited edition for the AIDS Foundation in Chicago through Fairytales Inc.; they received $100 from each bear. And then, I had the honor of having Arnold Schwarzenegger sign one of the bears I made for the Warner Bros. charity auction. I believe all people are different, therefore all bears should be. So, I really prefer to make one-of-a-kind bears, except for a good cause or a shop. I also usually do a Christmas edition. All of my bears have a tag hanging from the back of the neck that reads "Kelly & Company." I don't prefer a cloth tag sewn into a seam. However, now I've started to put a very small heart with my company name stitched unobtrusively under the left arm. I make bears that are traditional and the most popular are loosely jointed and softly stuffed with a well-loved look. I only use natural fabrics such as mohair and alpaca. The greatest pleasure I get from making bears is the act of taking a flat piece of material and turning it into a 3-D object that has personality, movement, depth and a variety of textures. There is a certain magic in both the creation and the sharing of that creation. I usually offer five sizes of bears in two styles. Also available are some other animals such as rabbits, pigs, mice, and birds.

Began selling retail: 1982
Price range:$95 (10in/25cm) - $400 (24in/61cm)
Approximate annual production: 100-120
Approximate number of shows per year: 8-10

Illustration 38. Kelly Dauterman.

Joanne R. Denietolis
American Pie Bears
Plymouth, MA

I have always had a passion for anything nautical. Living on the ocean and being married to a merchant marine for 20 years contributes to this theme. Many of my bears reflect this in their sailor attire. My distinct hallmark is my detailed costuming. I never know when to stop. A bow is never quite enough for me. I am constantly taking crafts courses that interest me and enhance my traditional style Teddy Bears. Smocking and Nantucket Lightship basketry are two such skills that add that special touch to my bears.

Began selling retail: 1983
Price range: $50 (6in/15cm) - $300 (24in/61cm)
Approximate annual production: 250
Approximate number of shows per year: 6

Illustration 39. Joanne R. Denietolis.

Jean Flowers
Jeanie's Wee Treasures
Placentia, CA

I really love dolls' houses and miniatures. I wanted to fill a nursery in my dolls' house with tiny stuffed animals. That led me to make my first tiny teddy bear. All of my bears are signed and dated. However, my real "trademark" is the tiny handmade wardrobe trunk in which they come. People are amazed at these wee treasures and the detail of their little outfits. Since I work full time, I only attend two shows a year. Even before I went back to work full-time I'd find myself up until the crack-of-dawn working on a new bear idea and filling orders. Sometimes I need to remember to get plenty of sleep and exercise. That's as important for creativity as anything!

Began selling retail: 1991
Price range: $60 (1in/3cm) - $130 (2in/6cm)
Approximate annual production: 150
Approximate number of shows per year: 2

Illustration 40. Jean Flowers.

Illustration 41. Jean Flowers' real trademark is the tiny hand-made wardrobe trunks in which her "wee treasures" come. Her precious little creations range in size from 3/4in-2-½in (2cm-6cm).

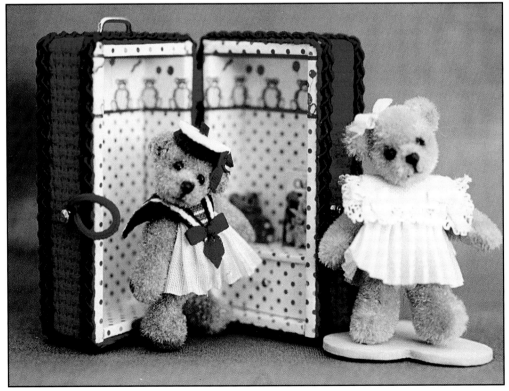

Karen Garfinkle
Reno, NV

My bears have a wide variety of looks from finely dressed Victorian lady bears to cute character bears dressed simply in coveralls. The character bears are probably the most popular. I've been featured in several books and magazine articles, but what brings me the most pleasure is expressing my creativity and seeing people appreciate my bears. I feel fortunate to work with my husband, John, who helps me stuff and cut out bears. He also helps me in the selling of the bears as well as taking pictures we use for advertising. Right now I concentrate on shows out West, but I do hope to do some shows in the East and maybe, someday, in other countries.

Began selling retail: 1976
Price range: $70 (10in/25cm) - $300 (22in/56cm)
Approximate annual production: 150
Approximate number of shows per year: 5

Illustration 42. Karen Garfinkle.

Sharon Gregori
Beary Treasures
Santee, CA

I do not have any formal art training, but have always been creative. When I was a child, I would sit and design gowns and outfits for my paper dolls and *Barbie* dolls. When my children were growing up I would design and make unusual Halloween costumes. My youngest son, Michael, was my biggest challenge. One year, he insisted on being a "duck-billed platypus." My first bear making classes were with the truly gifted Joan Woessner. In 1990, with my husband Tony's urging and loving support, I began doing bear shows with my best friend, Bonnie Leach, another wonderful bear artist. Today I make bears of all sizes, but prefer the larger ones. I love the Victorian style and frequently design dresses and hats in that style. I also love to make whimsical bears and will often create a wizard, guardian of the forest or similar design. Most recently I have been making bears from old fur coats. I also teach classes in making teddy bear jewelry and bear making. With so many wonderfully creative artists making bears, designing new and unique bears is always a challenge.

Began selling retail: 1990
Price range: Mohair $125 (10in/25cm) -
$320 (25in/64cm)
Real fur $155 (10in/25cm) - $350 (25in/64cm)
Approximate annual production: 100-115
Approximate number of shows per year: 6-8

Illustration 43. Sharon Gregori.

Mark & Sandy Hudson
Red Land Bear Co.
Oklahoma City, OK

We were inspired by a children's book we were writing about a misfit animal that had the physical qualities of a cat, a bear and a hare. We developed a prototype of the character and it looked more like a bear than the storybook creature we imagined. While the book was never published, it gave us the idea to make teddy bears. We didn't know how to sew, nor did we know there were bear-making workshops, teddy bear magazines or a teddy bear club 30 minutes from our home. We learned how to make bears by reading library books and studying the one Steiff bear we owned. Today we are glad we didn't have those influences. It cultivated an originality that is evident in our bears. We produce our creations with the help of four others. One cuts pattern pieces out of mohair, two machine sew the bodies and one helps with costuming. Sandy orders materials, sews heads, faces and sews bodies. Mark designs patterns, joints and stuffs the bears, and does the airbrushing. All of our bears are made from imported English and German mohair. Depending on how we want the bear to feel, we use a combination of excelsior, polyester fiberfill and pellets (steel, plastic or glass). We always stuff noses with excelsior. People like our realistic designs that convey a feeling of movement. We accomplish this by incorporating bent arms, legs, wrists and ankles in our patterns. We try to design bodies that conform to the way a bear really lies, sits, stands or walks. And, we offer 15-20 new patterns a year. Our best selling bears are different from anything people have in their collection. In 1997 we won a Golden Teddy Award and a TOBY Award.

Began selling retail: 1996
Price range: $75 (8in/20cm) - $400 (20in/15cm)
Approximate annual production: 1,200-1,500
Approximate number of shows per year: 20 - 25

Illustration 44. Mark and Sandy Hudson.

Illustration 45. *"To Grandmother's House We Go"* (Top) *Riding Hood.* 1997. 13in (33cm); off-white mohair; glass eyes; excelsior, polyester fiberfill and steel pellet stuffing; fully jointed (wooden disks, bolts and lock nuts). Wears a red velvet cape with hood; holds a basket of red berries to take to Grandmother. (Bottom) *Forest.* 1997. 11in (28cm) tall x 13in (33cm) long; honey with dark backing mohair; glass eyes; excelsior and polyester fiberfill stuffing; fully jointed (wooden disks, bolts and lock nuts). Wears a wreath of leaves and vines. Part of the fairy tale series.

Carolyn Jacobsen

Billy Bears by Carolyn
Syracuse, NY

My first acquaintance with needle and thread came at my Grandmother's knee. She helped me learn about colors and patterns while piecing my first doll quilts. My bears are heavily influenced by my long time love of antique toys. The old style traditional bears are what I try to create. I especially like to work with vintage fabrics: buggy and sleigh blankets, children's teddy bear coats. My husband Bill makes wonderful reproductions of old toys for props to go with my bears. Although my bears have appeared in magazines, books and won ribbons and awards, my greatest achievement of all comes when someone picks up a teddy I've created and is captivated by a special face. I have taught workshops in New York, Florida and Illinois. There is a real joy in watching confidence grow and finally blossom with a "Wow. I really did this. I made a bear!" I am working on several new designs including a bear standing on all four legs with a wire muzzle, a yes-no bear and even an electric eye bear. I've learned some tricks which have been really helpful. For instance, in enlarging or reducing pattern, first trim away the usual 1/4 in (.65cm) seam allowance. When you have achieved your new size, add the 1/4 in (.65cm) seam allowance back. The seam allowance should stay the same and not be increased or decreased with the rest of the pattern as it distorts it. Also, when I am making a hard sole, free-standing bear, I use double faced carpet tape between the hard board and inside of the felt sole. That way when I'm stuffing the foot, the hardboard won't shift.

Began selling retail: 1985
Price range: $75 (3in/8cm) -$350 (24in/61cm)
Approximate annual production: 150
Approximate number of shows per year: 5-6

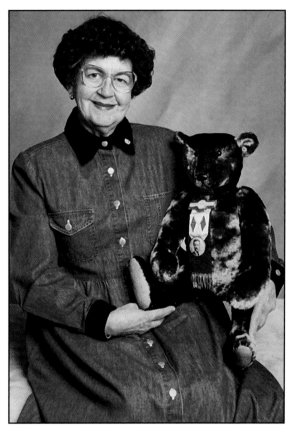

Illustration 46.
Carolyn Jacobsen.

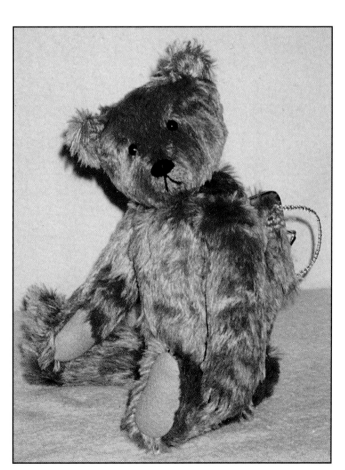

Illustration 47. *Pennies From Heaven.* 14in (36cm); old gold German mohair; shoe-button eyes; fully jointed (lock nut-bolt/disc); nodder head. Inspired by Pocket Book Bear in the Stratford-on-Avon Museum, England. Enclosed in purse are 5 new (1997) pennies. Limited edition of 6.

Jill S. Kenny
J.K. Bears
Milton, VT

I create teddy bears for adult collectors which are made from the finest quality, predominantly German mohair, incorporating antique shoe button eyes, ultra-suede paws and hand embroidered noses. My designs include longer arms than usual and hump backs. Many of my bears wear antique accessories, primarily a ribbon, bell or lace collar. I really have just one design, but I do it in different sizes in both traditional colors and my hand-dyed mohair. My larger bears are dressed in vintage clothes. I also do a limited edition Halloween bear and Santa bear each year. My bears are filled with plastic pellets to give them a wonderfully soft huggable feel. I also do a double cotter pin head joint so my bears' heads can sit at angles adding another dimension to their personalities.

Began selling retail: 1987
Price range:$148 (13in/33cm) - $270 (20in/51cm)
Approximate annual production: 500
Approximate number of shows per year: 25

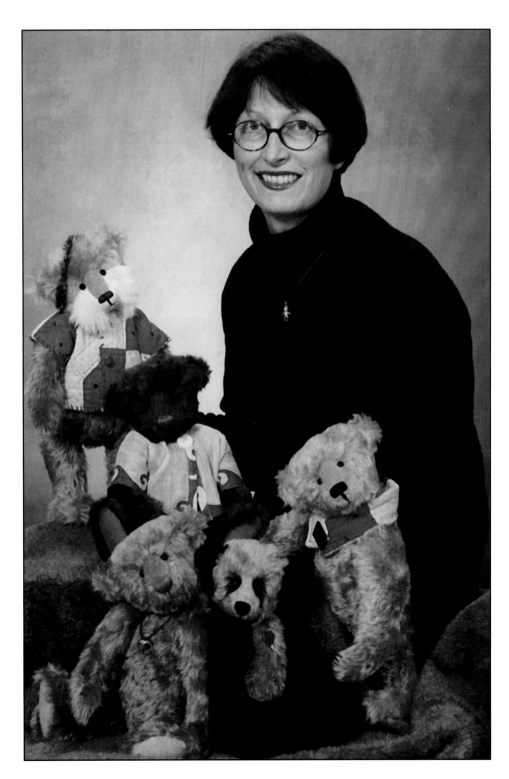

Illustration 48. Jill S. Kenny.

Ellen Kislingbury
Kislingbears
Pasadena, CA

I have designed and made teddy bears for more than six years, working from my home in Pasadena. I do all of the work, from concept and design to final construction exclusively. Additionally I create and design prototypes for the L.L. Knickerbocker Co., and The Annette Funicello Collectable Bear Co. To date they have produced approximately 20 of my designs for their retail line and for the QVC shopping channel. My bears are rather traditional in feel, with an emphasis on personality and charm. They have a unique and sweet expression. On the whole, I prefer to make bare bears with only the illusion of a costume and love to incorporate beautiful trims, laces and ribbons. I really prefer to work in mohair. On rare occasion I will use a high quality synthetic to achieve a certain effect or to experiment with. The heads of the bears are always stuffed with polyester fiberfill. Bodies, arms and legs are usually filled with a combination of plastic pellets and polyester fiberfill. All bears are also filled with love!

Began selling retail: 1992
Price range: $95 (6in/15cm) - $300 (24in/61cm)
Approximate annual production: 200
Approximate number of shows per year: 14-16

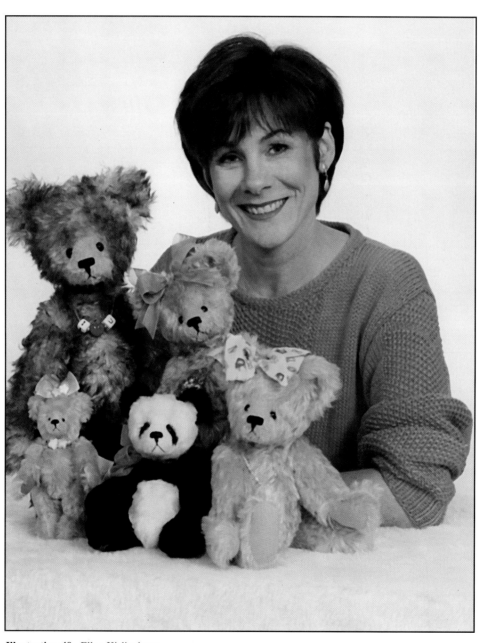

Illustration 49. Ellen Kislingbury.

Bonnie M. Leach
Vista, CA

My instructor Joan Woessner and my best friend Sharon Gregori inspired me to make bears. The hardest task in bear making was getting the jointing done right. Finally I accomplished this when my husband invented a joint turner for me using cotter pins. Most of my bears are ladies and I specialize in hats and methods of hat making. Since my bears are small, I had to come up with a method of hat making which was adaptable to their size. Those with a touch of vintage are my most popular creations. When sewing my bears, the most used tools in my studio are upholstery pins in both the 3in (8cm) and 4in (10cm) size. These are also used for gathering, turning bears and setting my hat forms.

Began selling retail: 1992
Price range: $75 (7in/18cm) - $145 (18in/46cm)
Approximate annual production: 100
Approximate number of shows per year: 6-8

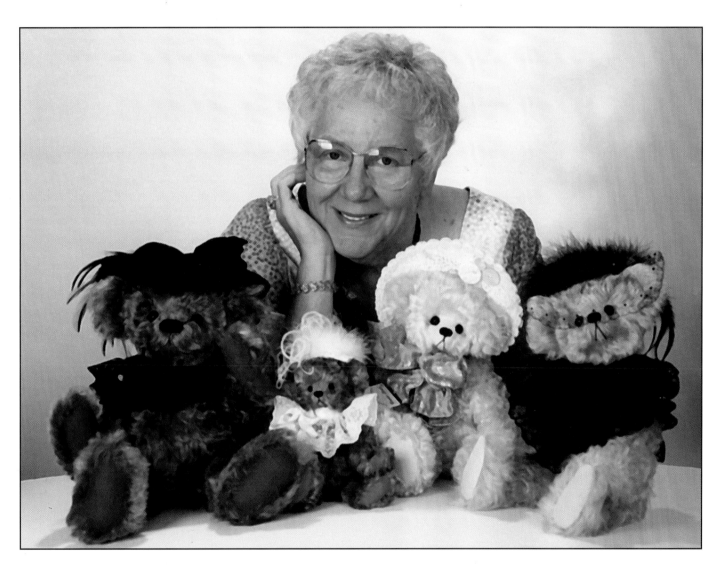

Illustration 50. Bonnie M. Leach.

Lori Leeper
Furbearsake
Exeter, ME

I have always been an artist longing to support myself through my art. Creating teddy bears provides the medium. The bears I create are heirlooms and I take great pride in knowing that my creations are one of a kind. My first show was the Kennybearport Teddy Bear Show in 1996. I don't advertise because I can hardly keep up with demand as it is. So word of mouth and shows keep me going without a real job. The bonus of this world is that it allows me to be a stay at home mom.

Began selling retail: 1996
Price range: $100 (11in/28cm) - $500 (16in/41cm)
Approximate annual production: 150-200
Approximate number of shows per year: 15

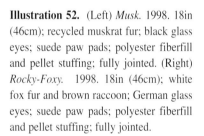

Illustration 51. Lori Leeper

Illustration 52. (Left) *Musk.* 1998. 18in (46cm); recycled muskrat fur; black glass eyes; suede paw pads; polyester fiberfill and pellet stuffing; fully jointed. (Right) *Rocky-Foxy.* 1998. 18in (46cm); white fox fur and brown raccoon; German glass eyes; suede paw pads; polyester fiberfill and pellet stuffing; fully jointed.

Cindy McGuire
China Cupboard
Marion, OH

My background is in fashion design. I am a graduate of the Fashion Institute of Technology in New York. This is undoubtedly why designing and being able to incorporate antiques and vintage fabrics and dressing my bears are the best part for me. I started collecting dolls in 1983 and the china heads became my favorites quickly. Fix-er-uppers became my specialty and I developed a small business refurbishing other collectors' dolls and redressing them. My collection quickly outgrew my home and I started to do doll shows to weed out my collection. When I ran out of antiques I started to make dolls and bears to fill the spaces on my sales tables. The dolls never seemed to have the panache the bears did and soon stores were calling me. I have a cottage industry and a staff of four.

One lady cuts and sews, one does the joints, one stuffs and closes, and one sews the clothing. Family members join in at busy times and my husband helps me with technical problems. Many of my bears have been shipped to Australia, Singapore, Germany, Canada and Japan. I also do workshops in conjunction with signings. These include "Dress an 8 in (20cm) Bear Using Grandma's Hanky," "Draping Garments and Developing a Cottage Industry."

Began selling retail: 1992
Price range: $100 (4in/10cm) - $450 (15in/38cm) - $1,000 (45in/114cm)
Approximate annual production: 750
Approximate number of shows per year: 30

Illustration 53. Cindy McGuire.

Flora Mediate

Flora's Teddys
Pasadena, CA

I had no idea what an adventure was beginning in 1980 when I made that first bear. I retired from teaching art when my daughter was born and began to sew soft toys as a hobby. "Once Upon a Time" in Montrose, California, who were selling some of my work, requested a teddy bear for their first Teddy Bear Christmas event. Since there were no patterns available I had to guess. It must have worked. The owner called me about a customer who would just visit one of my bears at the store. She thought she had made a sale, but he left the shop. The next day he returned to buy the bear. He told her his friend showed him a little bear he carried in his briefcase so he thought it would be a good idea to have a bear of his own. That was very encouraging. Coincidentally, when I designed my first bear it was dark brown with a light muzzle. Several years later my mother located a photo of me holding a teddy bear at the age of three. It too was dark with a light muzzle! I am proud to say I won Best of Show at the 1989 California State Fair. I also received a TOBY award for my bear *Filibuster* in 1996.

Began selling retail: 1982
Price range: $65 (10in/25cm) - $200 (14in/36cm)
Approximate annual production: 20
Approximate number of shows per year: 3

Illustration 54. Flora Mediate.

Jackie Morris
Blacklick Bears
Reynoldsburg, OH

I like to make bears with a lot of body language. Some are jointed, but many are not. I like to create a feeling of motion in non-jointed designs, and make many asymmetrical non-jointed bears. My bears are very different from most. I have always marched to a different drummer. It has taken a long time for them to be appreciated for being very original. My most popular designs is *Maynard*, first made in 1991. He has special arms that allow him to show his emotions. Other very popular designs are *Wylie*, a polar bear who lies on his back and plays with his toes and *Little Bobbie*, a non-jointed cub who lies on his side and sleeps. Among the awards I've received are a Golden Teddy Award (*Shakesbear*, 1991) and a Golden George Award (*Kato*, 1995). I usually do shows in the U.S. every year plus three in Europe and the U.K. Traveling abroad with the bears has been wonderful to me. I have made really wonderful friends all over the world and seen places I had only read about in books.

Began selling retail: 1986
Price range: $50 (4in/10cm) - $195 (18in/46cm)
Approximate annual production: 300
Approximate number of shows per year: 6

Illustration 55. Jackie Morris.

Illustration 56. *Maynard.* 1991. 17in (43cm); tan distressed, two-toned mohair; antique shoe-button eyes; fully jointed. *Maynard* demonstrates three of his many poses—showing different emotions.

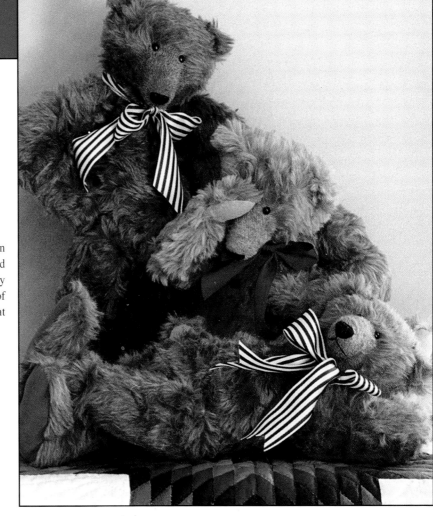

Margaret E. Newman
Maggie s Creations
Tully, NY

My sister-in-law and I were at an antique show; she saw bears created from antique crazy quilts. She prodded me until I started to create. She sold these at her antique shows. The early bears were created

Illustration 57.
Margaret E. Newman.

from hunter plaids, old paisleys, and crazy quilts. I then began to research teddy bears and shows. The next bears were created from recycled furs. These were definitely a hit. Over the past decade I've developed a very colorful style, using vintage fabrics, laces, jewels, recycled furs and stitching the noses with two-colored threads. I appear to be leaning more and more toward imported mohair these days. My bears seem to have a sense of humor and the most popular of these are nature bears and ladies. I only have one more year of teaching left and have been working to establish Maggie's Creations name identification through advertising in *Teddy Bear and Friends* and on my web site.

Began selling retail: 1987
Price range:$75 (6in/15cm) - $500 (21in/53cm)
Approximate annual production: 100-150
Approximate number of shows per year: 12

Illustration 58. *Mr. Bear Brummell.* 1996. 16in (41cm); white, string mohair; black glass eyes; fully jointed. Dressed in vintage fabrics, trims and jewels. Represents Beau Brummell, an English dandy who felt that men should dress in a flashy manner. *Photograph by Industrial Color Labs.*

Diana Lee Palomba
Timeless Expressions
Mansfield, MA

Bear artist Vicki Stephan inspired me to try bear making in 1993. The next year I began to sell my intricately detailed creations. I make mostly bears dressed with antique hats and accessories. Predominantly I lean toward limited editions of ten to 30 bears and many are one-of-a-kind.

Began selling retail: 1994
Price range:$130 (11in/28cm) - $600 (30in/76cm)
Approximate annual production: 100
Approximate number of shows per year: 6

Illustration 59. Diana Lee Palomba.

Illustration 60. *Brewster.* 1997. 24in (61cm); off-white English feather mohair; glass eyes; fully jointed (hardboard disks, bolts and screws). Brocade drapery cotton waistcoat. 1997 Golden Teddy nominee. Limited edition of 25. *Photograph by Images of Earth.*

Jim & Sue Parker
Parker People
Ann Arbor, MI

During our 15 years as doll artists, we were nominated and received numerous awards. We were the subjects of articles in major publications and known for the use of vintage fabrics for our doll's clothing combined with the antique patina of the dolls themselves. Perhaps our introduction to mohair fabric was a result of utilizing mohair pelts for doll wigs. We are new to the teddy bear world. As doll artists, we were known for the vulnerable look and have brought that aspect to our bears.

Began selling retail: 1996
Price range:$150 (14in/36cm) - $500 (28in/71cm)
Approximate annual production: 300
Approximate number of shows per year: 4

Illustration 61. Jim and Sue Parker.

Illustration 62. (Left) *Bear.* 1997. 22in (56cm); hand-dyed gold standard density curly mohair; black glass eyes; excelsior, polyester fiberfill and pellet stuffing; fully jointed; wobble head. Hand-made hat from vintage materials. Vintage dress with cotton net overlay. (Center) *Bellhop.* 1997. 14in (36cm); dark honey sparse curly mohair (trimmed); black glass eyes; excelsior, polyester fiberfill and pellet stuffing; fully jointed; wobble head. Hand-dyed red and black 100% wool felt outfit is incorporated into body, arms, legs and hat. Hand-dyed gold trim. (Right) *Bear.* 1997. 20in (51cm); hand-dyed grey sparse curly mohair; black glass eyes; grey leather paw pads; excelsior, polyester fiberfill and pellet stuffing; fully jointed; wobble head. Vintage cotton knit undershirt with red wool scarf.

Evelyn Penfield
Penfield Bear Stores
Escondido, CA

At a time I new I needed a new direction in my life, I happened by a craft store that advertised teddy bear classes with Joan Woessner. I fell I love with those little bears and the very idea that they could come to life at my hands continues to amaze me to this day. I made bears morning, noon and night. I entertained myself by the hour experimenting with designs, colors and anything I could think of. Then I joined the San Diego Teddy Bear Artist Club and decided to make bears full time and try my hand at actually selling my bears. Because I like to try things out, no bear is really ever finished. Trying to get 25 bears ready for a show took me forever. I decided to try a more streamlined method for the next show, but again it took me forever to get any large amount of bears ready. I was always changing ... I have such appreciation for the discipline it takes to participate in sales and shows and knew that was not necessarily my strength and that I would do much better to develop my interests in designing bear patterns and teach bear making. It was a great decision. Now I regularly teach in southern California, across the U.S. and abroad for stores that carry my patterns. One recommendation I make to my students is when using sparse fur, use smaller eyes than the pattern calls for. On dense fur, the opposite is true. Use larger eyes than the pattern calls for. I have a catalogue with a wide range of bear patterns available and never tire of designing new patterns and making new bears. I have actually disciplined myself to prepare for shows.

Began selling retail: 1992
Price range: $50 (5in/13cm) - $300 (30in/76cm)
Approximate annual production: 100
Approximate number of shows per year: 5-6

Illustration 63. Evelyn Penfield.

Neysa A. Phillippi
Purely Neysa
Indiana, PA

My bears are definitely not traditional. Europe describes them as "not normal." Currently my bears have long large noses, long skinny bodies, bent arms and/or legs. I feel as an artist one must change to grow creatively...and constantly. I don't make it a practice to enter contests. My collectors' praise and confidence in my work is better to me that any award or ribbon, even though I have won a few! I have presented a workshop/design class at Teddybar Total (Germany) with Georgene Palka and one in Tampa at the Bearly Spring Show to name two. I love to travel and I'll teach just about anywhere. My most rewarding accomplishment (besides being in the bear business and being self-sufficient for 14 years) is guiding tours to Europe for artists and collectors. My bears are predominantly character bears in open-end editions, with an average of no more than 35-50 of a design. How the collectors receive a particular bear determines how many I make. How many I make also depends on my newest idea, old creations give way to new ones constantly. My limited editions are created when I find some unique fur in Europe on one of my trips.

Began selling retail: 1983
Price range: $125 (12in/31cm) - $275 (24in/61cm)
Approximate annual production: 150-500
Approximate number of shows per year: 17-20

Illustration 64. Neysa A. Phillippi.

Illustration 65. *Bring On the Clown* 1997. 17in (43cm); various colors of English ultra sparse distressed mohair; German plastic eyes; recycled plastic pellets and polyester fiberfill stuffing.

Roberta Kasnick Ripperger
4 Creative Design Studio
Elmhurst, IL

I was taught to knit before I started school by my mother and Grandmother and picked up other skills as I grew older and became more interested in what are "historically" women's arts. I have A.P.N.R. (American Professional Needlework Retailers) accreditation for and have taught knitting, tatting and crochet to adults and children. My sister, Rosemary Green, of California and England, started Tedi Bach Hug miniaturists club in England in

Illustration 66. Roberta Kasnick Ripperger.

1991. She invited me to attend a S.M.A. L.L. Tea Party in Arizona. At that time I was closing a ten year old custom knitting business. Mary Fran Baldo gave the Tea Party Participants a kit for her *Tucker* bear and a few months later I made it up. I was hooked! I gave myself one year to improve my skills and signed up for my first teddy bear show with ABC Productions, Unlimited in 1992. Most of my creations are one-of-a-kind or very small editions of two or three. For shops (Teddy Bears of Witney in Oxford, U.K. and Cheri's Bear Essentials in Kansas City, Missouri) I make Exclusive Limited Editions of 20 to 25. My bears have a tiny charm sewn to their upper back that looks like an upside-down tulip. It's a jewelry finding called a Bell Clasp. Since I am a cottage industry, I have to do it all. My hardest tasks are bookkeeping, attaching ears and gearing myself up to meet the public at a show. Once I'm at the show you'd never know how shy I feel because I never stop talking once I get there. I've received nominations for a Golden Teddy Award (1995) and a TOBY (1996).

Began selling retail: 1992
Price range: $85 (2-1/2in/6cm) - $150 (3in/8cm)
Approximate annual production: 75-100
Approximate number of shows per year: 6

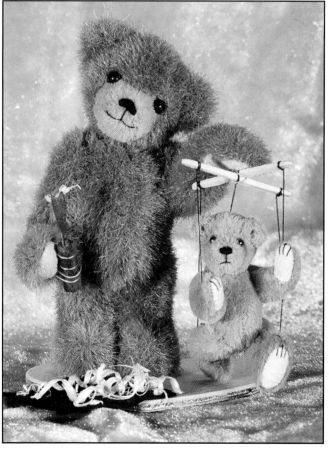

Illustration 67. (Left). *Proud Papa: Baby's First Steps-The Papa.* 1995. 3-¾in (10cm); tan German synthetic plush, ultrasuede paws and pads, upholstery fabric muzzle; black silk thread vertically stitched nose; dark brown goldstone bead eyes; jointed arms and legs; stationary head. (Right) *The Baby.* 1995. 2in (5cm); light tan upholstery fabric, ultrasuede paws and pads; black silk vertically stitched nose and claws; hematite eyes; fully jointed. Baby is suspended by strings. The limbs are controlled by the marionette sticks.

Tracey Roe
Roley Bear Company
Turlock, CA

My mother, Barbara Conley and I are partners in Roley Bear Company. We make bears in our homes. My mother is not only my partner, she is my best friend and inspiration. My parents collected antique dolls so we were familiar with showing and selling these types of collectibles. If you are an artist or have ever lived with an artist you know they are always seeking new ways to express an inner need to be creative. Throughout my childhood my mother was always busy learning new crafts. One day she suggested we try making a bear. I had already become quite an artist, so I couldn't say no. That was more than 13 years ago and I haven't quit making bears since. About five years ago I began stuffing most of my bears with excelsior. I love the weightlessness and the feel it gives my bears. I have a very difficult time if I have to make two bears look alike. Each time is a new challenge. The bear takes form and comes to life as I work on it. I have entered many contests and have won an award at every contest I have ever entered. One of my proudest moments in bear making was when Ashton-Drake asked my mother and me to send a bear and it was accepted for production. *Addie* can now be found in 12 different outfits, one for each month. Recently my mother and I were also nominated for a Golden Teddy award for *Grandmother and Samantha* a set of bears also produced by Ashton-Drake.

Began selling retail: 1983
Price range: $125 (6in/15cm) - $600 (25in/ 64cm)
Approximate annual production: 25-50
Approximate number of shows per year: 1-2

Illustration 68. Tracey Roe.

Illustration 69. *Maggie.* 1995. 16in (41cm); caramel distressed mohair; glass eyes; excelsior and polyester fiberfill stuffing; handmade vest, handband and flowers. Limited edition of ten.

Eva May Roettger
Bearly Eva's Den
Southbridge, MA

I design, cut, sew, assemble, stuff and create character and personality into each and every one of my bears. I plan to retire from nursing in five years and will have more time to create more teddies and widen my range in teddy bear shows. Now I'm only attending a few a year and my creative output varies greatly. They are all sizes from miniature to 3 feet (91cm) tall. Their style may be contemporary to antique, serious to whimsical. What they have in common is they are all loveable with their embroidered noses, charming smiles and soft-sculptured features. One of my most popular is *Rufus* because he's so huggable and safe for children.

Began selling retail: 1986
Price range: $45 (2-½in/6cm) - $225 (23in/58cm)
Approximate annual production: 50-100
Approximate number of shows per year: 5-6

Illustration 70. Eva May Roettger.

Illustration 71. *Morning Star and Desert Moon.* 1997. 17in (43cm); rust mohair; black glass eyes; Dacron® and pellet stuffing; fully jointed; hand-painted suede leather dresses. Representing Native American Medicine Women.

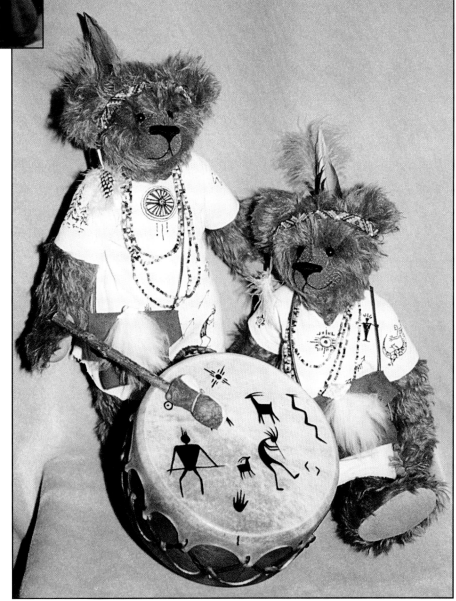

49

Judy M. Scott
Cubby B. and Friends
Tacoma, WA

Illustration 72. Judy M. Scott.

My love of teddy bears began in childhood. It started with my grandmother and an old bear named "Old Ted." He was a 1906 American-made mohair bear dressed in a military costume. He has long been my favorite companion and confidant. In the early 80s, I began to collect Steiff bears and miniature artist bears. I always was fascinated with the details of miniatures and felt that I could make them too. In 1986 I attended a workshop given by Kimberly Port. All I completed was a head mounted on a dowel with a ruffled collar; however, it took me hours beyond class to finish it. I was surprised when Kimberly asked if she could take a picture of us together with my first attempt at bear making. Her kind words and support were an inspiration to me. My first sales experience was when I air-expressed 18 bears to Morgan and Jerry Jordan (J&M Uniques) the day before the first Clarion, Iowa, convention in 1990. They called at midnight with the news the bears had sold before their table was set up! Since then my bears have always managed to sell themselves. As an artist and occupational therapist I often give educational workshops to bear artists. I stress that conserving your joints is very important. The wrist has a tendency to drift away from the body. Try to think of ways to structure activities so that motion is directed inward towards the body. For example, stuff bears so that your hand is directed towards your thumb. Evaluate how you use your tools. Make note of the type of movements that cause signs of fatigue. Try to balance these actions with opposite responses. Pain is a signal to listen to change what you are doing and rest. If it continues, consult with your physician.

Began selling retail: 1990
Price range: $120 (1in/3cm) - $250 (4in/10cm)
Approximate annual production: 75-100
Approximate number of shows per year: 2-3

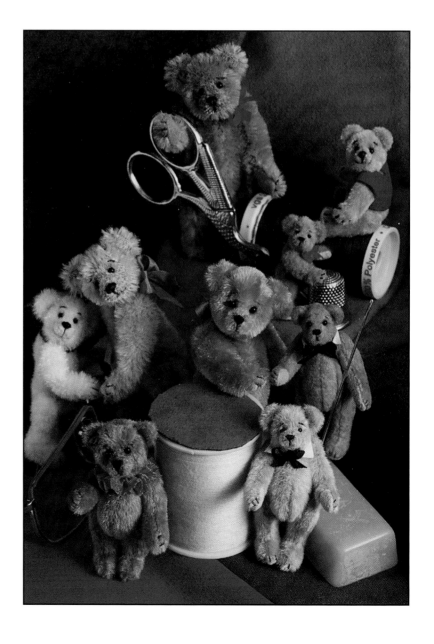

Illustration 73. *Cubby and Friends.* 1992-1996. 1in-3-½in (3cm-9cm); bears made of mohair and upholstery fabrics; black onyx eyes; hand-sewn; fully jointed. Group photo with artists glasses, scissors, thimble, thread, beeswax and needle to denote size in proportion to bears. *Photograph by Amelia N. Ates.*

Karen Searl
Karen's Treasures
Georgetown, MA

I love old bears, so I try to capture a traditional look I have won a few awards at local shows, but the best award by far is the look on the new owners face. My mom does all my stuffing for me and is irreplaceable. I try to change the designs a little each year. I sign and date each on the foot and also sew in a tag in the back seam.

Began selling retail: 1986
Price range: $70 (4in/10cm) - $395 (30in/71cm)
Approximate annual production: 300
Approximate number of shows per year: 12

Illustration 74. Karen Searl.

Sue E. Siebert
Siebert Bears
Pepperell, MA

As a child I had a thread-bare panda that my parents somehow managed to coax away from me. To this day I'm not sure what became of him, although I suspect he met a sorry end in the trash. Perhaps that's part of the reason why I now make my own teddy bears. I'm trying to recreate my long lost childhood friend. I made my first bear in 1993 after a friend showed me a few basics. These early bears were made of inexpensive synthetic fur purchased from a local fabric shop and at the time, I thought they were fabulous. However, when I look at them now I'm embarrassed. They look like a cross between space aliens and ugly dogs. It wasn't until I bought an issue of *Teddy Bear and Friends* that I decided to pursue bear making more seriously. The magazine revealed a whole new world to me and I finally had access to all the materials I needed to make a really top quality teddy bear. I like to create bears that possess an old-fashioned charm, yet are clearly my interpretations. I want their faces to be sweet, but not too sweet. And they have to have personality. I work very hard on the faces, making them seem almost alive. I am basically a one-person operation, although when things get particularly busy my mother helps cut out the bears.

Began selling retail: 1996
Price range: $135 (13-½in/34cm) - $230 (18in/46cm)
Approximate annual production: 125-150
Approximate number of shows per year: 3-4

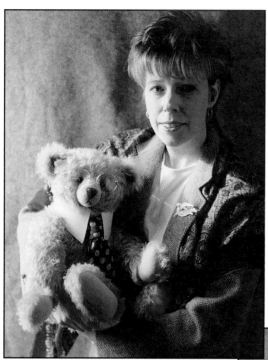

Illustration 75. Sue E. Siebert.

Illustration 76. *Elliot.* 1997. 17in (43cm); golden tan vintage finish English mohair; black German glass eyes; polyester fiberfill and pellet stuffing; fully jointed. Brown leather collar with bell.

Donna Steele
the button box
Colorado Springs, CO

I collected teddy bears for a long time. About five years ago I discovered artist bears made from mohair. After that I became an avid collector. I also dabbled on and off with bear making, but began to make real bears from my own designs. I always enjoyed sewing crafts and quilting and have a pattern company called Colorado Country Crafts which started with my soft sculpture doll patterns. Now I have included some bear and bunny patterns in this line. I work alone on my one-of-a-kind bears and you can identify my creations by their sweet faces, and a vintage button sewn on the bear's bottom with the bear's name year of birth and my initials written on the button.

Began selling retail: 1997
Price range: $110 (10in/25cm) -
$199 (18in/46cm)
Approximate annual production: 100
Approximate number of shows per year: 5

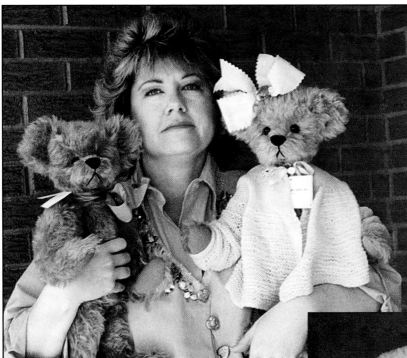

Illustration 77. Donna Steele.

Illustration 78. (Left) *Fillmore*, (right) *Nellie*, (front) *Tippi*. 1997. 10in-12in (25cm-31cm); beige shades of mohair; glass eyes; polyester fiber-fill and pellet stuffing; fully jointed.

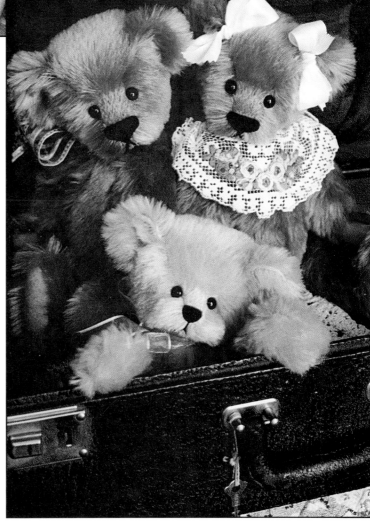

53

Diane Turbarg
Bear in the Woods
Westbrook, CT

My most popular design is my "teddy necklace" which I first made in 1994. I still get orders on that one! I make about five different sizes and many designs. I prefer to work in vintage fabrics. Perhaps the most consistent characteristics in my bears are the pale yellow color glass eyes and the way I remove the color from the back of the fabric. I have been making teddy bears for 19 years. To me, that's a great achievement and probably why I have never entered any contest. I still have a little empty feeling when I have to put one of my teddy bears in a box and ship it off!

Began selling retail: 1982
Price range: $98 (2in/5cm) - $450 (30in/76cm)
Approximate annual production: 300
Approximate number of shows per year: 9

Illustration 79. Diane Turbarg.

Illustration 80. A representation of Diane Turbarg's 1997 custom dyed *Teddies* in sizes 17in-30in (43cm-76cm).

Debra A. Weiss
Debra Weiss Bears
Escondido, CA

I had the pleasure of selling artists bears in my antique shop. Their beauty and craftsmanship intrigued me. Additionally, my sister-in-law enjoyed bears because of their warm, friendly nature and encouraged me to try making bears—primarily so I could teach her to make them. Bear making continues to inspire me because there are very few rules when making a bear which makes for an abundance of individual creativity. I can follow my inspiration as it leads me to new creations. I truly enjoy designing a bear and seeing that design come to fruition. Seeing each bear's personality develop and the pleasure my customers communicate when they select one of my bears as their own is very rewarding.

Began selling retail: 1994
Price range: $140 (9in/23cm) - $595 (26in/66cm)
Approximate annual production: 200
Approximate number of shows per year: 4-10

Illustration 81. Debra A. Weiss.

Illustration 82. Debra Weiss is known for producing sweet-faced vintage style bears dressed in antique-style outfits. Pictured are popular designs in sizes from 12in-20in (31cm-51cm).

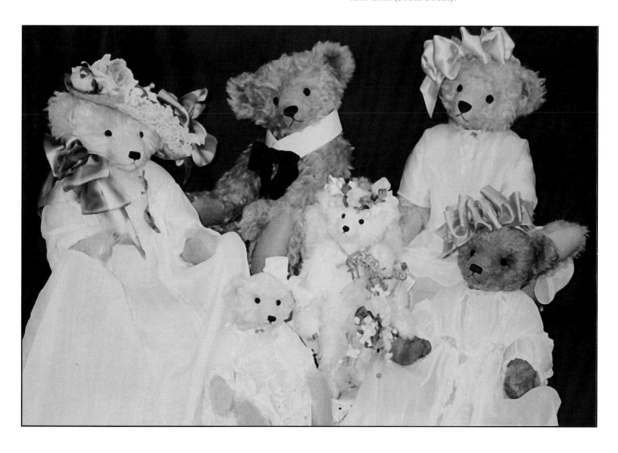

Geri Williams
Vintage Advantage Bears
Rainier, WA

My bears always have soft sculptured toes and stuffed ears. At first I made children's bears from acrylics; then I switched to collector bears from vintage fur coats and fabrics. These days I work almost exclusively with mohair, with the exception of a few vintage pieces. The bears tend to be tall and thin and many wear one-of-a-kind period costumes. I design all of the clothing and prefer to use vintage materials.

The bears often carry vintage accessories. In addition to selling bears, I also teach classes in bear accessories, hand painted teddy tote bags, bear clothing designs and teddy and dog construction.

Began selling retail: 1985
Price range: $45 (7in/18cm) - $200 (17in/ 43cm)
Approximate annual production: 250
Approximate number of shows per year: 10

Illustration 83.
Geri Williams.

Terry John Woods
Blackwoods Design
Shrewsbury, VT

My love for early German bears inspired me to begin making old-looking, old-feeling bears. Over the past decade I have been making pre-1910 German-looking bears and selling them at shows. It is a trial getting the bears out there. Vermont seems so far from the bear world. I work exclusively in German and English mohair, stuffing with excelsior and pellets. I really like creating something that makes me smile and collectors smile. Making an old-style bear out of new materials can be quite a challenge.

Began selling retail: 1987
Price range: $175 (12in/31cm) - $750 (27in/69cm)
Approximate annual production: 50-75
Approximate number of shows per year: 6

Illustration 84. Terry John Woods.

Illustration 85. *Bear.* 27in (69cm); German sparse mohair; shoe-button eyes; excelsior and pellet stuffing; center seam head; fully jointed. Rendition of a 1910 German bear.

Robert Zacher
Robert Zacher Originals
Waukesha, WI

I have been a teddy bear artist for about two years, however my designing technique came from repairing dolls at my bear and doll hospital and shop. It was on a tour of Germany that I decided to create my own bears. In my first year of bear making I received a great honor and was nominated in both *Teddy Bear Review* and *Teddy Bear and Friends* for an award. I also received a fourth place award in a teddy bear competition in Germany. I have sold my bears to shops, museums and a Broadway show! All my bears are one-of-a-kind creations with many joints (waist, wrists, neck and even ears). Limbs are wired for additional mobility. I employ many cloth sculpture tricks on faces and use a variety of modeling skills on sculpted faces. Sculpted faces and body parts (i.e., noses, claws, eyelids) are my favorite method because I can apply many of my doll making skills to the bears. For instance, appliqueing a lower mouth only with additional felt tongue and teeth gives much more character to the conventional look. Also, I increase the use of natural light and shadow to give a bear a much more desirable profile I sculpt the face with a needle and thread prior to applying noses, ears or eyes. I teach many of these tricks in classes on bear making.

Began selling retail: 1996
Price range: $65 (6in/15cm) - $300 (18in/46cm)
non-mechanical - $450 (18in/46cm) mechanical
Approximate annual production: 200
Approximate number of shows per year: 5

Illustration 86. Robert Zacher.

Illustration 87. (Left to right). *Herk, Tassles, Quirk.* 1997. 14in-16in (36cm-41cm); honey colored German mohair; fully jointed (wired limbs). Hand sculpted faces of Cernit with painted features.

CHAPTER THREE

Australian Teddy Bear Artists

Jennifer Laing:

Teddy bear making in Australia by one of the original artists.

Compared to the U.S., the art of making teddy bears has evolved fairly recently in Australia. Since the early 1980s, individually created teddy bear designs have been made and sold, but there were less than a dozen of these bear makers scattered around a huge continent. I believe I was the first Australian artist to work solely in mohair. Up till that time supplies were impossible to get and there were no classes or books available.

In the early 1990s, bear making supplies began to be commercially imported. The first suppliers were originally frustrated bear artists who didn't have appropriate materials on hand. Gerry Warlow of Queensland was possibly the first of these. She started off importing English mohair and then German Schulte mohair through Ron and Elke Block at Edinburgh imports. Gerry, whose supply business is still undoubtedly the best-known in the country, designs many kits and patterns.

There are now approximately 40 suppliers of varying sizes around Australia.

Along with this recent boom in the number of suppliers is the surge in the number of people learning how to make their own bears. 1994 saw the country's first International Bear Fair in Sydney, and now annual bear shows in all States attest to the popularity of artist bears. Our country now has several bear magazines, as well as an annual advertising guide. From about 12 professionals in 1990, there are well over 200 bear makers and artists working around the country. Possibly around 30 to 40 % of these bear makers are full-time bear artists and about 20% teach their craft to others.

Each State in Australia seems to have at least one teddy bear club, and these are mostly non-profit groups. As well as sharing information and friendship among fellow arctophiles and artists, the clubs often have fund-raisers for worthwhile charities focusing on bears in the wild. It is wonderful to see bear artists and bear collectors extend their love of teddy bears to caring about the plight of real bears.

Rae Hargrave
Teddies to Love
Melbourne, Australia

Yes, I must confess. Making teddy bears helps me support my own teddy bear collecting addiction. I love artist's bears. The creativity of other artists amazes me, but one day, I hope to own a lovely old Steiff, I make lots of different styles of bears. I enjoy the challenge of trying to create realistic style bears, but with a softness and touch of whimsicality in their expressions. From my first competition, I was winning Best in Sections consistently at shows. The greatest thrill of all was a TOBY nomination for my Polar Bears. These Polar bears, *Nanouk* and *Coy* won Australian Bear of the Year in 1997. I enjoy doing set-in faces, so I mainly use a combination of mini mohair and upholstery velour. I stuff my bears mainly with nylon fiberfill; I like the firmness. Sometimes I use glass beads in the tummy. I have been teaching for nearly two years now. I really recommend doing a workshop or more with a reputable teacher if you are just a beginner. A great deal is learned in a class with hands-on experience you can apply to other patterns. I have discovered that design workshops were invaluable since I could sketch, but had no drafting background.

Began selling retail: 1995
Price range: $200 Aust (4 in/10cm) -
$260 Aust (6 in/15cm)
Approximate annual production: 100
Approximate number of shows per year: 3-4

Illustration 88. Rae Hargrave.

Illustration 89. *"The Guardian".* Bear. 1997. 5in (13cm); mottled brown upholstery velour; German glass eyes; ultrasuede paw pads; nylon fiberfill stuffing; hand-sewn, soft-sculpted paws and claws; fully jointed. One-of-a-kind auction piece. The guardian protects two seals, made of upholstery velour, hand-stitched and detailed. Antique lace and net drape tin base.

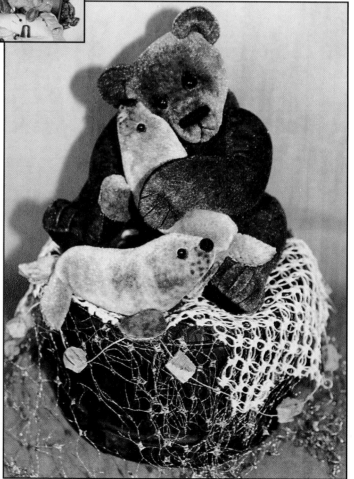

Heather Helbig
Furry Tails
Victoria, Australia

I started making bears just a short time ago when I decided I wanted to have a more creative and flexible way to express myself than making antique reproduction dolls. I still make dolls and have won a few awards from the Doll Artisan Guild. My retail sales are through "Dolls in the Attic and Bears too" Balwyn and Scot and Tot in Sassafras. I also sell through the *Bear Facts Review* Magazine. It keeps me very busy. I look forward to the time when I can give up my part time job and do this all the time. In the meantime, look for my green and gold Furry Tails labels in the seam of my bears. Maybe soon I'll be reaching out internationally.

Began selling retail: 1997
Price range: $65 Aust (3-1/2 in/ 9cm) -
$450 Aust (15 in/38cm)
Approximate annual production: 100
Approximate number of shows per year: 6

Illustration 90. Heather Helbig.

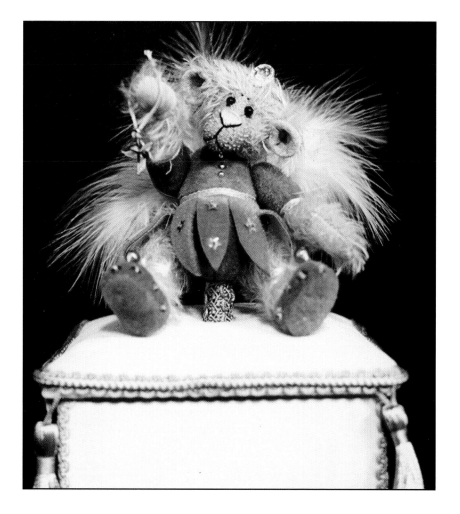

Illustration 91. *Blue Fairy.* 1997. 5-½in (14cm); light tan mohair and cream shadow suede; black bead eyes; fully jointed (hand sewn disc and split pin); wobble head. Outfit an integral part of body. Star sequined dress and shoes with bells; feather wings; treasure box: padded, covered in off white shadow suede, trimmed with gold and blue braid. Blue Fairy looks after your special treasures. One-of-a-kind. *Photograph by Richard Outram.*

Rebecca Hurley
Nature Teds
Roxby Downs, Outback
South Australia

There is a time in bear creation when I look at a bear and he looks me right in the eye. I love to be able to breathe life into my bears. I started out creating conventional bears, but for the past two years I have been perfecting my wild style realistic bears. I've learned that no idea is too crazy or impossible to achieve. Recently I converted from polyester fiberfill stuffing to wool noil, as I find it gives a more uniform consistency for the limbs and head. The body is filled with pellets for softer, more life like feel and more poseability. My bears are distinctive in their realistic design with sculpted leather noses and paw pads and leather claws. They often have a tinted face. As I prefer to be completely in control of creating a bear to my own specifications, I work alone. I am particularly proud when I am invited to work on fund raising auctions.

Began selling retail: 1993
Price range: $115 (9in/23cm) - $350 (20in/51cm)
Approximate annual production: 150 bears
Approximate number of shows per year: 2

Illustration 92. Rebecca Hurley.

Illustration 93. *Grizzle.* 1997. 20in (51cm); caramel English mohair; black German glass eyes; sculpted brown suede paw pads; sculpted leather nose; hand-painted leather claws; painted face. Polyester fiberfill stuffing (head and limbs); plastic pellets (body). One-of-a-kind. Designed for Christie's December 1997 fundraising Artist Bear Auction to benefit Libearty.

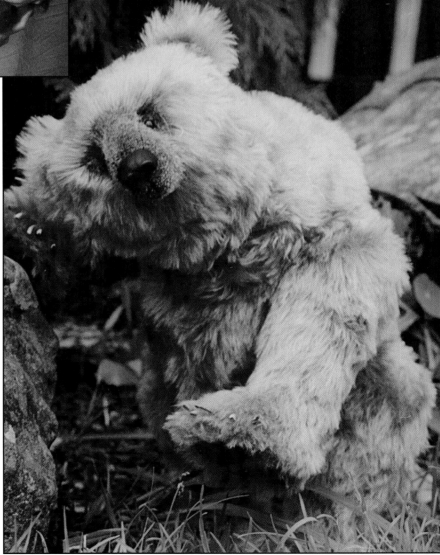

Sharyn & David Hutchins
Brookside Bears
Tasmania, Australia

When we teach workshops here in "Tassie," students like the fact that they get two artists for the price of one. We both share equally in all we do. Sometimes we work together on one bear and other times we work on individual projects. We enjoy creating a mixture of different looks: contemporary character bears to very traditional antique styles. Our styles and designs are constantly evolving and changing, as we discover new things. We have been honored with several awards at leading bear shows in Australia, particularly the Premier Bear Affair in Sydney in 1996 and 1997. We would very much like to travel overseas with our bears. Many of our bears have journeyed further than we have!

Began selling retail: 1995
Price range: $80 Aust (7 in/18cm) - $350 Aust
(for larger and limited editions)
Approximate annual production: 200-250
Approximate number of shows per year: 4-5

Illustration 94. Sharyn and David Hutchins.

Illustration 95. *Molly Flops"*. 1996. 18in (46cm); tan sparse mohair; glass eyes; polyester fiberfill stuffing; fully jointed. Tea dyed cotton dress and headband with bow.

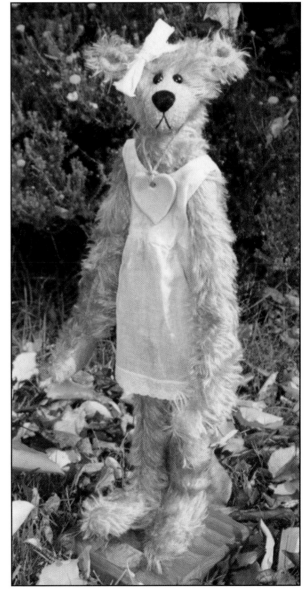

Jo-anne Noorman
Jo's Tiny Teddy's
Victoria, Australia

About three years ago, after making bears for a couple of years, people started to comment on the look of my bears. I thought "hey," people might actually pay money for these! And they did. I started off at a small craft market and rapidly progressed from there. I just love creating something that you can feel, hold, hug and love out of something that is virtually flat and lifeless, such as a piece of mohair. My bears are a little offbeat, you might say. They have what I call a certain cartoonish quality to them. All of them have big noses and big feet. My most popular design ever has been a gold mohair bear of about 8 in (20 cm) who carries either around his neck — or under his arm— a smaller mohair bear. Both have adorable expressions on their faces. It gives me a real buzz when I see the look of sheer delight that people get when they see one of my bears that really appeals to them.

Began selling retail: 1995
Price range: $55 Aust (4in/10cm) -
$100 Aust (8in/17cm)
Approximate annual production: 70-100
Approximate number of shows per year: 5-6

Illustration 96. Jo-anne Noorman.

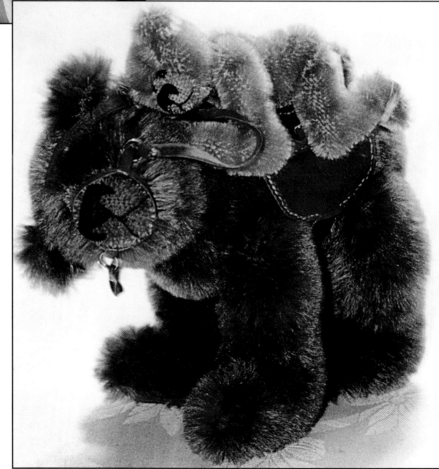

Illustration 97. *Griswald.* 1996. 6in (15cm); dark brown mohair; black glass eyes; brown leather paw pads; fully jointed. Hand-made leather saddle and bridle. *Gauci* (Jockey). 1996. 3in (8cm); short honey colored mohair; black glass eyes; brown leather paw pads; fully jointed. Limited edition of 5 (sets).

Petra Wasse
The Old Bear Company
Perth, Western Australia

Illustration 98. Petra Wasse.

I have no professional art background, but have always loved to create things. For a while, I was very involved in handcrafting puppets on a string. All my puppets had character faces. Faces just fascinate me. I also love drawing portraits. In 1978 I lived in Paris. I was continuously broke and found I could make some money by drawing portraits of tourists at Montmartre. I made my first bear in 1995 and the next year the Old Bear Company was founded. My first show was the Premier Bear Affair in Sydney (Australia) where one of my bears won a first prize. I've also won a few awards on the Internet. My bears are very traditional. They all have long limbs, long snouts and big tummies. In keeping with tradition, I work only with mohair and leather or felt for the pads. Most of my old looking bears are stuffed with wood wool to give them an authentic feel. Some people don't like working with wood wool. It is quite stiff and messy, but it can be softened by spraying it with a fine mist from a water spray can. I found it works even better just to place a small wet towel in a plastic bag containing the wood wool. If this is done a couple of hours before you start working with it, the moisture of the towel will have made the wood wool much more manageable.

Began selling retail: 1996
Price range: $100 (11in/28cm) - $225 (22in/56cm)
Approximate annual production: 100
Approximate number of shows per year: 3

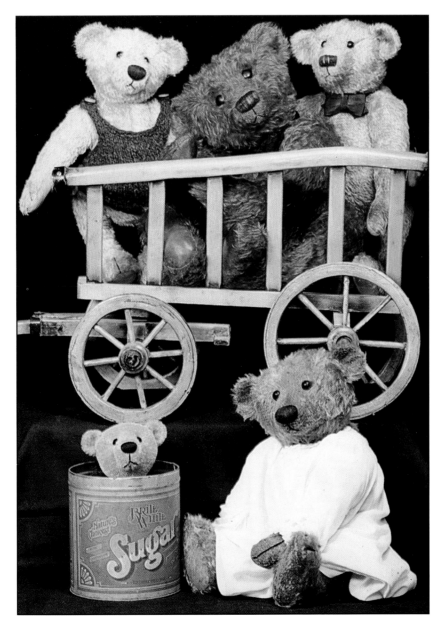

Illustration 99. (Top left to right). *Oscar, Bronco* and *Alfred.* (Bottom, left to right) *Tiddles* and *Miss Daisy.* 21in-11in (53cm-28cm). 1996-1998. All bears are made of mohair, with glass or shoe-button eyes, and are stuffed with wood wool, polyester fiberfill and pellets and are fully jointed. *Photograph by The Victorian Photo Co.*

Jacki Williams
Bare-Belly Bears by
jacki williams®
Victoria, Australia

When my sons Marcus and Cameron were born in 1990 and 1992, I received bears for them, made by the late Pat Lovelock. When I looked at these bears I was inspired to take a one-day workshop with Pat which gave me a start into the world of bear making. My greatest thrill to date was achieving a "Best in Show" award in August 1997 for my bear titled "Will I ever learn to juggle?" The fabrics I use for my bears ranges from acrylic (for cuddly, affordable child-safe range) to mohair and old coats. I create traditional looking bears which are most often bare and big enough to be cuddled. If my family and friends don't claim the bears that I have made this year, I will look forward to selling at as many shows as time permits.

Began selling retail: 1994
Price range: $120 (8 in/20cm) - $300 (20 in/51cm)
Approximate annual production: 30-35
Approximate number of shows per year: 2

Illustration 100. Jacki Williams.

Illustration 101. *Will I Ever Learn To Juggle?* 1997. 15in (39cm); white recycled fur coat; glass eyes; ultrasuede paw pads; polyester fiberfill and pellets stuffing; fully jointed (lock nuts). Hand-painted accessories. One-of-a-kind.

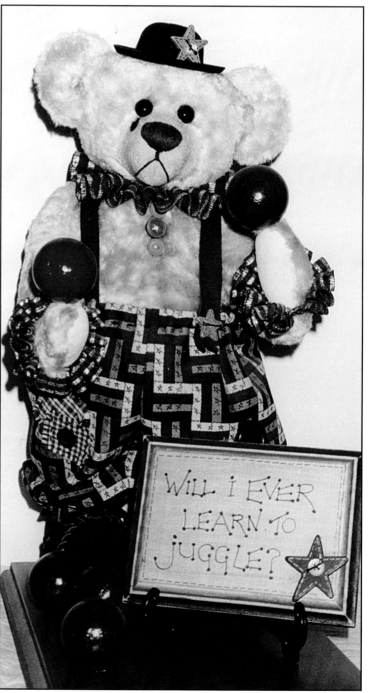

CHAPTER FOUR

Austrian Teddy Bear Artist

Karin Kronsteiner:

An originator of bear making looks at teddy bear artistry in her country and abroad.

In 1992 I was the first person I know of who started to design bears in my part of Austria. It was not possible to get mohair or other teddy bear components in my town of Graz. Television and newspaper reporters came to see them. The interest in teddy bears began to grow. Now about 30-50 people make bears in Austria, although none seems to work at it full time. At this time there is no Austrian Bear Club or a magazine for teddy bear collectors and artists. So, anyone who makes bears does it with little exposure. There are about three shows a year here in Austria. The one in Gmunden features both bears and dolls; there is one in Graz with different new bear-makers, and last but not least, my show in Graz. Because the number of bear makers here in Austria is so small, I look at all the bear artists in the world as one big family. I have learned to think not only within Austria, but globally!

Renate Hanisch
Bears from No. 27
Vienna, Austria

Even though I've won awards both in Europe and in the USA, one of my greatest accomplishments is teaching several bear making classes with the 1st Austrian Bear Shop, Purkersdor/Vienna, Austria. I have worked with beginners and taught pattern design. A favorite class of mine is for pupils 13 years of age, both girls AND boys! There doesn't seem to be just one type of bear that I make. However, they all have friendly smiles and have a little ultrasuede tag sewn in their back seam. When you come to my table at a show there are about 15 bears and they are all different. I use mohair (old and llama coats when available); sometimes for special creations I use deer skin! Most of my bears are one-of-a-kind.

Began selling retail: 1996
Price range: $185 (7in/18cm) - $650 (20in/51cm)
Approximate annual production: 100
Approximate number of shows per year: 5-6

Illustration 102. Renate Hanisch.

Illustration 103. *Banoffee.* 1997. 20in (51cm); 3 shades of hand-dyed German mohair; Austrian glass eyes; polyester fiberfill and pellet stuffing; fully jointed. Expresses his favor for Banoffee Pie (banana and toffee) in body shape and variety of color; the fur is pieced together (40 pieces) reflecting the layers of Banoffee Pie. *Photograph by Christoph Weber.*

Belgian Teddy Bear Artist

Helga Torfs
Humpy Dumpy Bears
Meerhout, Belgium

Illustration 104.
Helga Torfs.

My boyfriend is a teddy bear collector and when he first asked me to make him a bear it was a disaster. But I didn't give up. Each bear improved. I particularly enjoy making bears with bent legs that can be posed and dressed up. You can see an example of my classic bear, named *Isi* on the leaflets and flyers announcing the British Bear Fair 97 in England. Many of my bears are thematic, such as Indian tribe bears, Eskimo bears, and Dwarf bears. It's very time consuming! I always want to make sure to find the right materials for the right bears. My boyfriend and I even visited Indian clubs in Germany to make the original accessories of a particular tribe. We also try to make a new set-up every year. For instance, when we had the Indian theme, we showed the bears with a teepee, a totem pole, and an Indian horse. The only bear that is an open-end is *Pedro*, the Humpy Dumpy mascot bear. He appears on all my cards and tags. The others are limited editions or one-of-a-kinds. A great tip I have discovered is the use of kite-line. It is very strong and since it will never break it is excellent for fastening eyes!

Began selling retail: 1995
Price range: $100 (8in/20cm) - $400 (21in/55cm)
Approximate annual production: 100
Approximate number of shows per year: 8

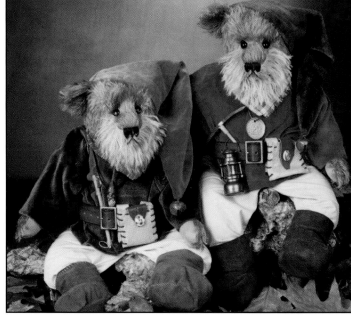

Illustration 105. (Left) *Drommels*, (right) *Wijzebaard*. 1997. 21in (53cm); beige shades of sparse mohair; pellet and synthetic stuffing; fully jointed; air-brushed face and paw pads. Dressed as a gnome in old fabrics. *Drommels* won the public prize in Ahoy, Rotterdam, Holland in 1997. *Photograph by Ben Boeckx.*

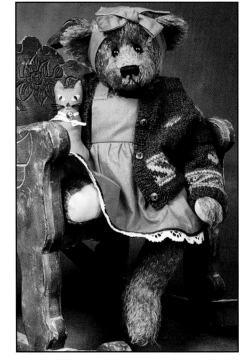

Illustration 106. *Klaartje.* 1996. 17in (45cm); old brown English mohair; black Austrian glass eyes; plastic pellet and polyester fiberfill stuffing; fully jointed. Wearing a pink cotton dress, head-bow, hand-knitted Shetland woolen cardigan holding a little cuddle cat. Limited edition of 8. *Photograph by Ben Boeckx.*

British Teddy Bear Artists

Elaine Lonsdale:

The British Bear Market.

In the four years since I started making teddy bears I have seen three major changes in the UK marketplace: the growth in the number of teddy bear artists which I estimate as nearly double; the growth in the number of teddy bear fairs (there are five major shows in London alone and there is hardly a weekend which does not feature a fair); and a shift in the types and varieties of bears sold from the still popular traditional bear to more exclusive and individual bears. British artists have access to the world's best mohair. Other essential ingredients for teddy bear making, such as plush fabrics and construction supplies, are readily available. For example, artists and importers around the globe agree that one of the finest mohair fabric mills is Norton's, which is headquartered in the United Kingdom. This fact, along with our proximity to Germany, give our bear artists a distinct advantage when it comes to acquiring the right materials for creativity and craftsmanship.

These changes and benefits have increased competition and thus, the need for bear artists to find a unique style to make their bears more distinctive. Artists who are very original are experiencing unprecedented demand.

Sarah Bird & Alexander Loughi

Cotswold Bears
Worcestershire, England

We live and work in a beautiful Cotswold village, in a 17th century thatched cottage which used to be the town dairy. We first became interested in the teddy bear industry when we were commissioned to fully design and build a teddy bear museum in the Cotswolds. We fell in love with old and modern bears alike and attended a teddy bear course taught by Linda Graves, a long established English teddy artist. Thus we began to create our bears for the museum and ourselves. Finding them very popular with collectors we decided to launch our business. We create a wide range of bears, offering different styles for every kind of collector. We produce seven ranges of bears: "The Edwardian Collection," "Bears from the Attic," "The Jester Collection," "The Classic Jester Collection," "Back to the Wild," "The Flower Collection," and "The Shakespeare Collection." These range from traditional bears to realistic grizzly bears, jester clowns and fully costumed bears. In April 1996 we won a prestigious award at the British Teddy Bear Awards where we won the title, Best New Artist in the British Isles. Winning that award gave us much publicity and we gained many customers from our reputation for quality. Since then, several articles have been written about our bears and we are also very proud that our work is on display at the world famous Teddy Bear Museum in IZU, Japan. We had been teaching classes, but now we find ourselves too busy. We really enjoy the marketing of our bears as it allows us to use all of the marketing, advertising and design skills which we learned at college and in the workplace. We feel very proud and happy to own a profitable business at a relatively young age. Our identity is also reflected in our fair stand which we designed and which was built by a local carpenter from old wood complete with thatched roof and lantern lights.

Began selling retail: 1996
Price range:$125 (12in/31cm) - $900 (32in/81cm)
Approximate annual production: 350
Approximate number of shows per year: 20

Illustration 107. Sarah Bird and Alexander Loughi.

Illustration 108. *The Jester Collection.* (Back) *Eskimo* and *Livingston.* (Front) *Kenva, Leopard, Snow Leopard* and *Darwin.* 12in-17in (31cm-43cm); white and honey wavy mohair; Austrian glass eyes; fully jointed. The jesters' style encapsulates the same elements of regal luxury and fun-styled in the first jester bears of the early 1920s. A variety of beautifully rustic cashmeres and fur-feel velvets.

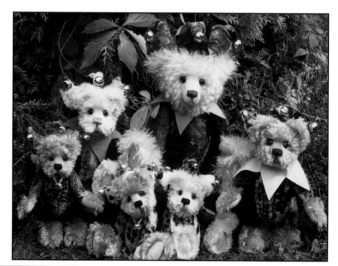

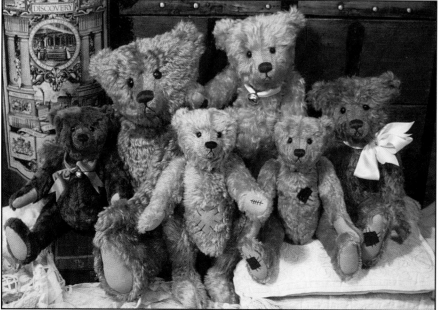

Illustration 109. *Bears From the Attic Collection.* (Back) *Balthazar, Quentin* and *Lucien.* (Front) *Clarice, Henry* and *Aaron.* 26in-14in (66cm-36cm); various length and types of quality mohair; black boot-button eyes; wood wool stuffing; fully jointed. Based on truly traditional antique bears. Designed with this in mind using old style mohairs and colors, traditional patterns reminiscent of the turn of the century. Some even come with complete patches and re-stitching.

Paula Cawley
Paula-Bears
Stoke-on-Trent Staffs,
England

A well-made bear is a piece of art. People look at it and sense something else going on beneath the surface. A good bear artist will create the illusion of life. I am quite well-known for my masquerade bears which look like children when they dress up for parties or pantomimes. I'm not going for realism, but a amusing and endearing look. My first go at it was a bear dressed in a cat-suit and this was followed quickly by a bear masquerading as a dog, another as a rabbit and a mouse. I've also done a spider, a crow, a monkey, a lion, an elephant and even a Welsh dragon. But they are all witty and unique bears...just dressed up! Many of these designs now incorporate hand-carved and painted wooden props. *Reginald* and *Douglas* fly vintage planes, *Harvey* rides a horse and *New Year's Day Dipper* is kept afloat with the help of a giraffe. I still enjoy working on traditional mohair bears as well.

Began selling retail: 1992
Price range: $200 (11in/28cm) - $500 (14in/36cm)
Approximate annual production: 100
Approximate number of shows per year: 6

Illustration 110. Paula Cawley.

Illustration 111. *Douglas.* 1996. 14in (36cm); sparse blue mohair (lower body) and oak gold mohair (upper); black glass eyes; wood wool and synthetic stuffing; fully jointed. Hand-carved and painted airplane. Satin wired scarf, leather flying helmet. Sitting in an airplane, his legs depict the sky. Airplane held on with braces and is removable. Propeller rotates.

71

71

Karin Conradi
Conradi Creations
London, England

I've always earned my living working with textiles. I've sewed for designers and restored antique clothing. I've always loved bears and have been collecting for quite awhile. My first was a limited edition Steiff replica and now I collect artist bears exclusively. I particularly admire the work of Pat Murphy, Audi Sison, and Lori Baker. These are just a few of the great artists out there who incorporate style, expression, tradition, and a special tactile quality that I look for. My own bears have to be tactile so only the most sensuous fabrics will do. I use only the finest mohair and alpaca and fill them with polyester fiberfill and pellets. The combination gives them a weight and flexibility that just feels right! Each bear is made entirely by hand, which means my output is slow, but my collectors think it's worth the wait.

Began selling retail: 1996
Price range: $150 (9in/23cm) - $175 (11in/28cm) - $200 (13in/33cm)
Approximate annual production: 150
Approximate number of shows per year: 1

Illustration 112. Karin Conradi.

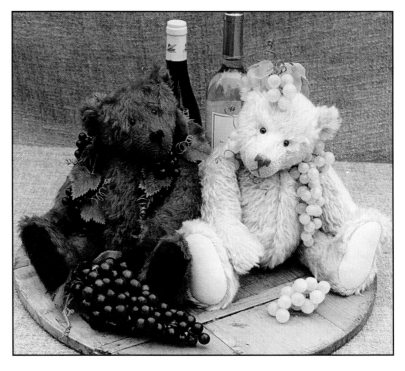

Illustration 113. (Left to right) *Beaujolais and Chardonnay.* 16in (41cm); maroon and soft gold mohair; glass eyes; ultrasuede paw pads; polyester fiberfill and pellet stuffing; fully jointed. Winner of the 1997 British Bear Artist Award. Category New Artist.

72

Linda Edwards
Little Treasures
Nottinghamshire,
 Great Britain

I have always enjoyed various crafts, embroidery was a favorite. I also made porcelain dolls and rag dolls at one time. The bears I create are mainly small. In the beginning I made larger bears too, but I would much rather work with little, sweet bears. In the early days I worked entirely alone. But, as my business grew it became difficult to keep up with orders. My husband Tony can often be found stuffing limbs. He has more muscle than me! And my Mum makes most of the outfits for the bears now too. I select the fabrics and design the garment. Quality bears take time to create and waiting time can often take many months. Some shops think they are ordering from a large company with lots of bears in stock!

Began selling retail: 1992
Price range:$158 (7in/18cm) -
$498 (special larger pieces)
Approximate annual production: 225
Approximate number of shows per year: 6

Illustration 114. Linda Edwards with a selection of some of her most popular 1997 designs. (Left to right) *Buttons, Felicity, George, Harry, Lottie,* and *Tilly.*

Claudia Hawkins
The Claudia Collection
Gloucestershire, England

My love for teddy bears started as a child. But, I have to blame my grandfather for the special feelings I have for pandas. He gave me a very large Wendy Boston Panda for my eighth birthday and from that time that bear became my best friend. I suffered continual bruises from falling over him as we attempted to dance around the living room. I take a great deal of time researching living bears and have a large collection of videos and books which I study and make sketches from. I watch how each animal moves and what its skeletal and muscle structure is like. It can take me up to six months of study before I even start to draw out a prototype pattern and anoth-

er six months of experimentation before the final design is ready to release. My bears, like people, all vary. I don't mark where the limbs are to be; I do this by feel. The same method applies to the eyes. The most useful lesson I learned as a working artist (I painted prior to making bears) was that no living creature is truly symmetrical. I actively encourage a natural feel in my work. After all, nature is perfect. So I carefully design my bears using artistic license in order to copy nature. You will not find a well-groomed bear in my collection. To give bears that scruffy look, I dye mohair in tea or coffee to give it a tonal range similar to real fur. To add to the realism many of the bears have leather claws. I take considerable time over the feet and hand sculpture the pads and muzzle which is often airbrushed. My emphasis on quality rather than quantity has paid off. I now exhibit at fairs around the world and was delighted to win a First Prize for my realistic pandas in the Panda Category and Second Place with a polar bear at Linda Mullins Show in San Diego (1997).

Began selling retail: 1993
Price range:$440 (17in/43cm) - $820 (22in/56cm)
Approximate annual production: 100
Approximate number of shows per year: 12

Illustration 115. Claudia Hawkins.

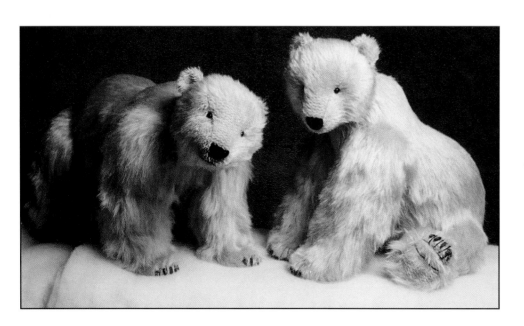

Illustration 116. *Eisbär* (English translation: Polar bear). 1996. 17in x 21in (43cm x 53cm); cream mohair; black glass eyes; mohair paw pads; (air brushed features in black), leather claws; fully jointed with double neck joint; airbrushed muzzle. This design won a "The Golden George" award for the "Bare Bear Category" at Teddybär Total in Germany, in April 1997.

Pam Howells

Pamela Ann Designs
Crowland, England

For a long time bears have been a part of my life. At 17, and after 18 months at Art College, I was appointed Assistant Designer at Chiltern Toys, a long established soft toy factory in south Wales which made the famous "Hugmee" bears. My very first design for Chiltern was for a non-jointed bear on a tricycle. After ten years as designer I had to leave, since my husband (a sculptor for the same company) was transferred to Lincolnshire. A few years after the move, I rented a small workshop about six miles from home. Continuing to design and make a variety of soft toys including bears, I have now been there for 22 years. For many years mohair was very difficult to obtain, however, I was sometimes able to buy small quantities from helpful suppliers. The bears I make are very traditional in style. From time to time I try more way-out styles, but usually come back to my ordinary bears which have nice gentle faces. I like to dress some bears in vintage clothing and also to decorate some with antique lace collars and jewelry. However, not all bears suit being dressed. I highly value the awards given to me by the British Toy Makers Guild for my bears and other animals.

Began selling retail: 1973
Price range: £50 (6in/15cm) - £250 (28in/71cm)
Approximate annual production: 300
Approximate number of shows per year: 16-17

Illustration 117. Pam Howells makes a variety of designs and sizes to the delight of her numerous fans. (Left to right) *Giant Panda, Amethyst, Baby Bear* and *Abigail.* All bears are made of mohair, have glass eyes, are fully jointed and were produced in 1997.

Jayne Loughland
Mystic Bears
North Wales, Britain

I have been in the entertainment business for 19 years. My brother and I had an international magic act and my husband Stuart and I continued on with our own illusion act while my brother found a new assistant. Since then, seven years ago, my husband and I have worked all around Britain. I mainly make my bears in dressing rooms; each swing tag states where the bear was made, as it is never in the same place. I cut out lots of bears when I'm at home so I can just pick up a bear wherever I am and sew. I find making small, miniature bears the most convenient as they don't require a sewing machine and I can make them on the road. I have been placed first and second in numerous bear competitions, including being nominated for a *Teddy Bear Times* Award in 1997, and came in runner-up in a National Bear Competition in 1996. I have a bear on display at the Teddy Bear Museum in Naples, Florida. Most of my bears are based on entertainers I know. This makes for some very intriguing characteristics. One of the most popular, to no surprise, is *Beardini* the magician.

Began selling retail: 1996
Price range: $50 (1-1/2 in/2cm) - $100 (6in/15cm)
Approximate annual production: 250
Approximate number of shows per year: 10

llustration 118. Jayne Loughland and her magician husband, Stuart.

Illustration 119. *Magician and Assistant.* 1996. 4in (10cm); honey velveteen; onyx eyes; fully jointed; hand-sewn. Satin jacket and trousers are an integral part of bear. This is one of the illusions Jayne and her husband perform. This piece was nominated for the 1997 British "Teddy Bear Times" award.

76

Nicola Perkins
Miniature Bears
Cheshire
United Kingdom

I owe a debt of gratitude to British miniaturist Deb Canham from whom I took courses and learned a great deal. For a time she was the only person making miniature bears in Britain. When I began making miniatures, there was a lack of collectors. However, over the years people began to appreciate the intricacies of miniature bears and to understand that they are equally as difficult and take equally as long to make as larger bears. The market for miniatures has strengthened and people are finally fully accepting them for the little masterpieces they are. I specialize in antique style miniatures with accessories and clothing. Each one is different and often dressed in handmade antique attire. I recently started housing some bears in Victorian cards which have a beautifully lined box attached to them. These are quite popular as the concept is unusual and people know that they have a unique piece. I have won a number of British Bear Artist Awards including a special one for the best overall entry which got me a trip to the Walt Disney World Convention!

Began selling retail: 1994
Price range: $162 (1-1/2in/4cm—undressed) -
$300 (5in/13cm—dressed)
Approximate annual production: 120
Approximate number of shows per year: 5

Illustration 120. Nicola Perkins.

Illustration 121. *Forget-me-Not.* 1997. 3in (8cm); golden yellow upholstery velvet; glass bead eyes; polyester fiberfill and steel shot stuffing; fully jointed. Lace and silk dress trimmed with cream and blue roses on shoulders. Ribbon at waist and a tiny lace butterfly on hand. Housed in an antique Victorian card with silk lined box attached.

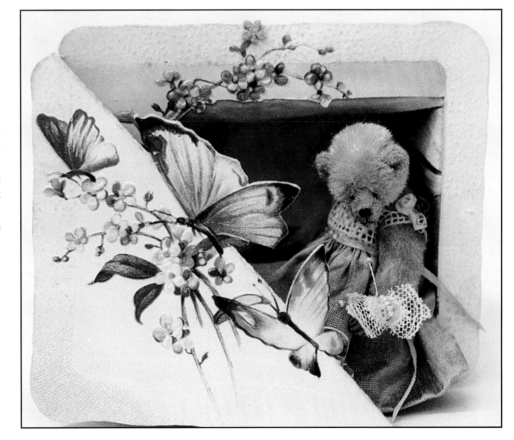

Christine S. Pike
Green Lizard Marketing
Hampshire, United Kingdom

It took me two years to finally create my "RealBear© Collection". I wanted to find a look that was naturalistic, without being frightening. Each one is exciting to create, because I never know what kind of character each one will have until I have sculpted the teeth and airbrushed the muzzle. I made so many prototypes for the open-mouth bears before I was happy. I almost despaired of ever getting it right! All of my bears have the proportions of real bears, rather than traditional teddy bears; they have small heads, large bodies and very big feet which enable them to stand unaided. The RealBears© are distinctive in their own right. They have smiling open mouths with two little hand-carved teeth in the bottom jaw. One of my great pleasures is having a presence on the Internet. My husband has built, and updates, my web site and it brings me into contact with people I could not have reached otherwise. The Internet provides me with a large amount of mail order business; but it is mail order with a difference: because of the immediacy and intimacy of E-mail, I build relationships with my customers that would be very difficult to achieve through other forms of advertising. I love being a part of an on-line community of bear lovers. It is like being part of a 24-hour virtual teddy bear show.

Began selling retail: 1994
Price range: $97 (6in/15cm) - $800 (23in/58cm)
Approximate annual production: 150
Approximate number of shows per year: 10

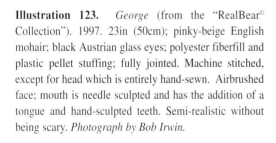

Illustration 122. Christine S. Pike.

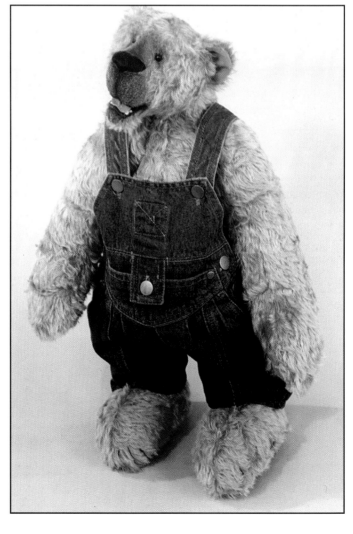

Illustration 123. *George* (from the "RealBear© Collection"). 1997. 23in (50cm); pinky-beige English mohair; black Austrian glass eyes; polyester fiberfill and plastic pellet stuffing; fully jointed. Machine stitched, except for head which is entirely hand-sewn. Airbrushed face; mouth is needle sculpted and has the addition of a tongue and hand-sculpted teeth. Semi-realistic without being scary. *Photograph by Bob Irwin.*

Kathryn M. Riley
Wirral, England

When Jenny, my daughter, was small I made and sold craft work at our local Craft Fair just for fun. I fully intended to return to full-time art teaching when she was older. After one such Fair in 1992 I delivered an order to a local woman and was captivated by her teddy collection. Until then I had no idea that adults collected bears. I was particularly drawn to the miniatures and having attempted my first tiny Ted discovered that this was something I could just "do." I won the Best New Artist at the British bear Artist Awards in 1993. Since then I have been honored with much recognition, including a TOBY Award (1996) for best Miniature Bear. I have traveled to the Walt Disney World Teddy Bear and Doll Convention as an invited artist for five years and have been asked to create auction pieces for charities around the world. My pieces are mainly one-of-a-kinds. I sell retail and occasionally wholesale to Hamley's Toy Shop in London and Walt Disney World. I thoroughly enjoy the challenge involved in making elaborate auction or competition pieces. They provide an opportunity to stretch my imagination and skill to a level that I may otherwise not attempt. I wish I had enough time to make all the ideas in my head.

Began selling retail: 1992
Price range: $90+ (1-1/2in/4cm) - (4in/10cm)
Approximate annual production: 150
Approximate number of shows per year: 3

Illustration 124. Kathryn M. Riley.

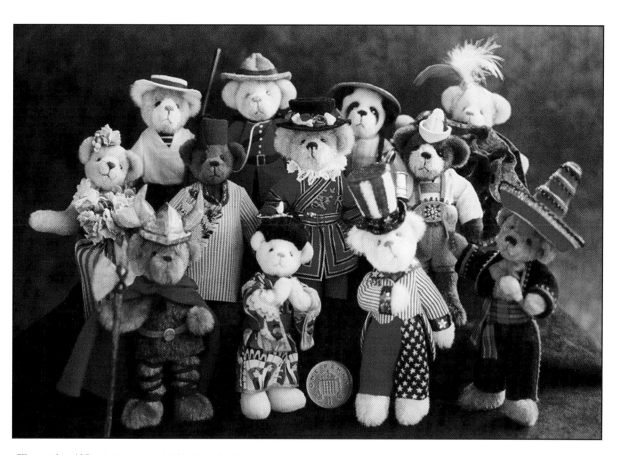

Illustration 125. *Nations United.* 1995. 3in (8cm); various types and colors of miniature plush; glass eyes; polyester fiberfill stuffing; fully jointed. Hand-stitched; dressed in various silks, cottons, suede and many types of trim. Each bear represents a country featured in Walt Disney World's® Epcot Center. Auction piece for 1995 Walt Disney World® One-of-a-kind Teddy Bear and Doll Convention. The theme for the convention was "International".

Sue Schoen
Bocs Teganau
Wales, United Kingdom

I truly enjoy the whole process of bear making, except maybe sewing on the ears and foot pads! I advertise in British teddy bear magazines, but mainly sell my sweet-faced, teddy bear creations at shops, shows and on the Internet! The opportunity to travel and make friends all over the world is a wonderful reward. I have also won formal awards such as the British Bear Artist awards and a nomination for a TOBY in 1994. One tip I'd like to pass on to newcomers is in regards to using bonded nylon thread which I use to sew in eyes. I've discovered it can sometimes be a bit springy. It becomes much more flexible after zipping it through fingernails or the blunt edge of a knife.

Began selling retail: 1987
Price range: Undressed $100 (7in/18cm) -
$200 (12in/31cm)
Approximate annual production: 750
Approximate number of shows per year: 8

Illustration 126. Sue Schoen.

I have always loved teddy bears. I still have my own childhood bear, purchased by my parents for my first birthday. He still wears his policeman's suit which I knitted him as a child! I began making bears when my company relocated and it gave me the opportunity to completely change my career! My miniature metal jointed teddy bears, most of which have long noses and muzzles, often find homes in snow scenes. In fact, I was nominated for a TOBY award for my *Winter Wonderland* vignette (1997). The year before I was the Public's Choice winner in the TOBY Awards with *Snow Fun with Benjy*. *Educating Peter* won the British Bear Artist Award in 1997. They are all totally hand stitched. I spend a lot of time on the heads and faces of my bears. Their expression is of utmost importance.

Began selling retail: 1994
Price range: $85 (1-¼in/3cm) - $200 (3in/8cm)
Approximate annual production: 100-125
Approximate number of shows per year: 4-5

Illustration 127. Kay Street.

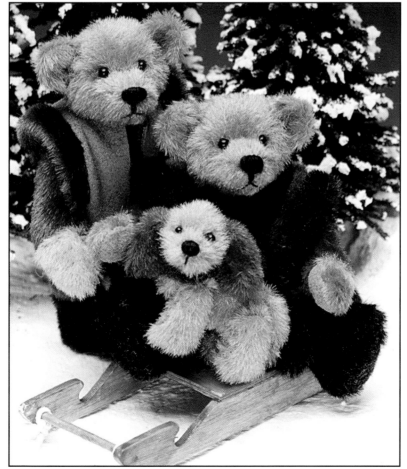

Illustration 128. *Snow Fun With Benjy.* 3in, 2-¾in and 1-¼in (8cm, 7cm, 3cm); sandy colored miniature long pile plush; onyx glass bead eyes; polyester fiberfill and steel shot stuffing; fully jointed; hand-stitched. Ultrasuede jacket with miniature long pile fur trim. Long pile fur coat. Set won the TOBY award in 1996.

Stacey Lee Terry
bo bear designs
Buckinghamshire,
England

Bo Bears consists of a team of seven staff members. Each and every one of us is essential to the success of Bo Bear Designs. Without everyone's dedication and skill we would not be enjoying the success we do today. I am responsible for the design and a large proportion of the Bo Bear facial features. I am also primarily responsible for the complexities of running a small business. Andrea Terry ("AJ") provides the huggable figures of all our bears. Steve Hampton again provides the huggable figures for the bears along with his exceptional model building skills. Sheryl Allen is the wizard on the machine. She is also solely responsible for the design and creation of all the magnificent Bo Bear costumes. Maureen Gowton takes full control of the cutting. She is responsible for ensuring that all fur is running the correct direction. Failure to do this not only results in a bear with somewhat abstract features, but also causes unmentionable suffering at the paws of fellow bears. Kay Fleming is in command of all the Bo Bear administration, not only organizing my schedule and endless list of to-dos , but connecting with every corner of the world. Last, but by no means least, is Dawn Bridge who is in sole command of the Bo Bear Gallery and has established an admirable relationship with our Fan Club members. We produce bears with personality, soul and attitude...not the cute, squashy cuddly type, but ones similar to your best friend, your favorite grandparent or your favorite movie star. They are alive and willing to share your life.

Began selling retail: 1989
Price range:$200 (7in/18cm) - $470 (18-½in/47cm)
Approximate annual production: 1,000
Approximate number of shows per year: 0

Illustration 129. *The Bo Bear Team:* Stacey Lee Terry—The Boss, Andrea Jane Terry—2nd in Command, Steve Hampton—Creative Technician, Kay Fleming—Administration, Sheryl Allen—Sewing, Costume and Design, Maureen Gowton—Cutting Technician.

Illustration 130. *Frank.* 10in (25cm); sparse mouse colored German mohair; black glass eyes; polyester fiberfill and lead shot stuffing; fully jointed. Aptly wrapped in a lambs wool tartan scarf to ward off those winter chills. A bear with a huge lung capacity to celebrate Christmas with all his brothers in full voice. Limited to 10 pieces worldwide and exclusive to Bo Bear Fan Club members. *Photograph by Harvest Studios.*

Frank Webster
Charnwood Bears
Leicestershire, England

My late brother-in-law Ned, a committed arctophile, got me into making a varied selection of bears in the traditional manner. I work alone, and, even though I have deliberately maintained a low profile in the bear world, I have been involved in projects with both Colour Box Collectibles of Scotland and The Deans Company in Wales. One of my hardest tasks in bear making was creating a bear for Colour Box called *Pirate Jake*. This involved the use of Loc-line arms, with a stainless steel hook and cup instead of the traditional paw and also a peg leg. Added to this I was requested to put in one normal eye but the other was missing and rather than leaving a plain surface under the eye patch I had to create an illusion of a damaged eye. I sell retail through The House of Bruin of which I am a joint partner with my wife Sue. I supply only three other shops, Sue Pearson, Pam Hebbs and Teddy Bears of Witney.

Began selling retail: 1988
Price range: $235 (14in/36cm) - $575 (36in/91cm)
Approximate annual production: 200-250
Approximate number of shows per year: 10

Illustration 131. Frank Webster.

Illustration 132. *Griz.* 1997. 23in (58cm); dark chocolate English mohair; acrylic black eyes; polyester fiberfill and pellet stuffing; fully jointed. Airbrushed for grizzled look. Limited edition of 15.

Canadian Teddy Bear Artists

Patricia Gye:
Bear making from a Canadian point of view.

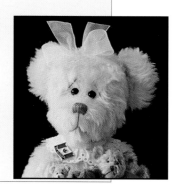

Teddy bears are becoming more popular here. They pop up all over the place and everybody seems to love them. The few shows we have are well attended by serious and well-informed collectors.

Only about one-quarter of artists make teddy bears a full time business. Most of us work in mohair and we mainly order from American importers such as Edinburgh Imports or Intercal. In general, bear making supplies are now fairly freely available, particularly in the larger cities, but they are very expensive. Canada is large and sparsely populated so supplies are more difficult to obtain in the boondocks!

There are no more than ten teddy bear clubs across our county, but new ones are starting up. There are about nine all teddy bear shows held here, but only six of them are major. Generally speaking, we don't seem to have as much disposable income in Canada for the public-at-large to seek out artist made bears. But things are vastly improving.

Overall, I have created more than 3000 bears. A few of them are dressed, some bare, and the rest simply accessorized to express their personalities. I frequently try to add a Canadian flavor to my bears either by costumes (my *Canadian Arctic* bear dressed in an Eskimo parka complete with mukluks and mitts), by accessories (toques, scarves, and mittens) or by naming them after towns in Alberta (Derwent, Stavely, Ridley, etc.) Most of my bears have eyebrows, giving them characteristically appealing "take me home" looks. My first TOBY award bear, *Binkie and his Bear*, was originally submitted for a contest and donation for the Bear Fair convention in Calgary (1994). When I arrived, I learned that *Binkie* had never arrived. We rescued him from the bottom of a bundle, but not in time for the contest. I always wondered how he would fare in competition. So, I decided to enter him in the TOBY competition. He won and the rest, as they say, is history. Over the past ten years I've learned to take pictures of each bear I make. It makes it easier to part with them, and it comes in handy when I need photos for magazines, books and contests. My best ideas come when I am falling asleep, so I keep a pad of paper and pen right by my bed. I've also gotten in the habit of answering all inquiries regarding my bears. People are disappointed when they don't hear back.

Began selling retail: 1988
Price range: $25 (1in/3cm) - $600 (26in/66cm)
Approximate annual production: 300-500
Approximate number of shows per year: 3-4

Illustration 133. Edie Barlishen.

Illustration 134. *"Dawn"—Bear Collector III.* 1997. 11-½in (29cm); yellow hand-dyed mohair; black glass eyes; polyester fiberfill and steel pellet stuffing; weighted to stand. Small bears are 1-¾in-4in (4cm-10cm). The third version of Edie's rendition of a bear collector. The first one, won a TOBY Award in 1996.

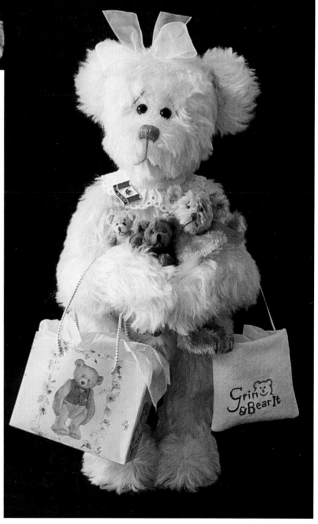

Barbara Buehl

Buehl Bears
British Columbia,
Canada

Because of my admiration for classic designs, I enjoy creating traditional bears that are fully jointed and have glass eyes. They are made from the finest imported mohair and alpaca fabrics. I usually accessorize my bears with handmade cotton bows to complement their fur shade. My bunny designs proudly wear one-carrot necklaces that I hand-sculpt from clay. I work strictly on my own, from the beginning stages of designing to selecting the right materials, cutting and stitching, stuffing, needle-sculpting and embroidering the features, accessorizing and tagging, packaging and shipping...a one-woman operation and a labor of love! I always strive to make more bears each year. My bears seem to be recognized for their unique expressions and classic proportions. Collectors tell me that my bears' eyes follow them around the showroom, urging to be taken home. I've also heard it said that they are good listeners and always appear well-groomed and ready to do a show. Since I began making bears I've learned a couple of tips I'd like to pass on to new (and maybe not-so-new) bear makers: the new spring-action scissors with padded handles make easy work of cutting fabrics. They can be used whether you are right or left handed and are great for preventing aching hands and wrists. I also use quilter's needle pulls which are small rubber discs that allow me to grip and easily pull stubborn needles through when embroidering noses or stitching on ears.

Began selling retail: 1989
Price range: $90 (8in/20cm) - $300 (24in/61cm)
Approximate annual production: 60-70
Approximate number of shows per year: 3-4

Illustration 135. Barbara Buehl.

Barb Butcher
Heartspun Teddy Bears
Alberta, Canada

I mainly create mini bears, but occasionally I make bears up to 11-1/2 in (29cm) tall. Most are made of upholstery velvet or mohair. In 1995, I won first place in the White Hat Teddy contest at The Bear Fair in Calgary, Alberta, Canada. The 2-1/2 in (6cm) bear was named *Merridew* and he also showed up on the May/June 1996 issue of *Teddy Bear and Friends* Magazine. I find great difficulty pricing my bears, especially since I work entirely on my own. Making teddy bears has allowed me to travel to places I wouldn't otherwise have seen and to meet some wonderful people.

Began selling retail: 1989
Price range: $75 (2-½in/6cm) -
$300 (11-½in/29cm)
Approximate annual production: 100-120
Approximate number of shows per year: 5-10

Illustration 136. Barb Butcher.

Lorraine Chien

By Lorraine
Ontario, Canada

As a close to 50 year old with the heart of a five year old, I am an oddball in the midst of a family devoted to science. My parents were both medical doctors and I came to Canada to study medicine. Instead, I met Eddie and got married. I am an avid collector of bears, animals and toys. I basically live and dream toys. I like to portray a teddy bear's purity, honesty, loyalty and earnest characteristics in a classic, unpretentious and clear way. My working sessions often last from early morning to past midnight, although I never consider it as work (except maybe just before a show!) Each creation has an "L" appliqued on the back. Being recognized as one of the unique plus designers has brought me ease and pleasure in marketing my bears. In 1995, I gave exclusive rights and license to GANZ Inc. (The largest teddy bear manufacturer in Canada) to manufacture some of my plush designs and through GANZ Cottage Collectibles umbrella I've reached many collectors. One of my plush designs (*Dempster*) won a 1996 Golden Teddy Award. Besides my bears, there are many resin figurines, pins & magnets, as well as decorated picture frames and wall covering products depicting my teddies and their friends. Like any other art, I believe, a teddy bear is very much the derivative of the inner disposition of its creator at work. A rush job often leads to a haphazard teddy bear. I don't dress my bears right away. I sit a bear somewhere where I can see it often and let it tell me if it wants to be male, female, dressed on not. I try not to have a pre-conceived idea of the character I want to create. I let the bear and my hands do the work.

Began selling retail: 1984
Price range: $100 (2in/5cm) - $600 (36in/91cm)
Approximate annual production: 300-350
Approximate number of shows per year: 3

Illustration 137. Lorraine Chien.

Illustration 138. *Emma.* 1997. 12in (31cm); cream colored mohair; safety eyes; polyester fiberfill and polyester pellet stuffing; fully jointed. *Emma* with her cat doll depicts the photograph in the frame of Lorraine when she was 4 years old with her cat doll. *Photograph by David Nooner.*

Illustration 139. *Gollys and Teddies. Lil Golly* 4in. (10 cm). *Big Golly* 10 in. (25cm); wool felt and mohair; antique shoe-button eyes; fully jointed. Teddies 4in.-12in (10cm-31cm); plush and mohair; antique shoe-button eyes; leather paw pads; fully jointed. *Photograph by David Nooner.*

Debby Hodgson
Homemade Hugs,
British Columbia, Canada

Besides meeting fascinating people, the most pleasure I get from bear artistry is when I draw a new pattern at night and the next day I cut it out, and it all goes together like magic. I always think some little angels must have helped me to create this little marvel. I love variety. My most popular designs lately have been the very tiny ultrasuede teddies 1in (3cm) or less. People seem fascinated with the tiny detail. Sometimes it is not good business to spend so much time on a bear, but I can't seem to stop until every detail is just right. Because many of my bears are very small, I like to make some type of container in which they reside.

For example handmade walnut prams, tiny hat boxes and even a wonderful tiny tin with painted flowers and a lovely silk rose bed inside. I also grow and dry my own flowers for wreaths and pot-pourri and this sparked a new line of potted flower teddies, each with potpourri filled tummies. *Daisy, Rose, Pansy,* and *Sunflower* completed this small edition. I also think it is fun to have little bears you can take with you safely as wearable tiny teddies.

Began selling retail: 1986
Price range: $95 (2in/5cm) - $275 (17in/43cm)
Approximate annual production: 40-60
Approximate number of shows per year: 3-4

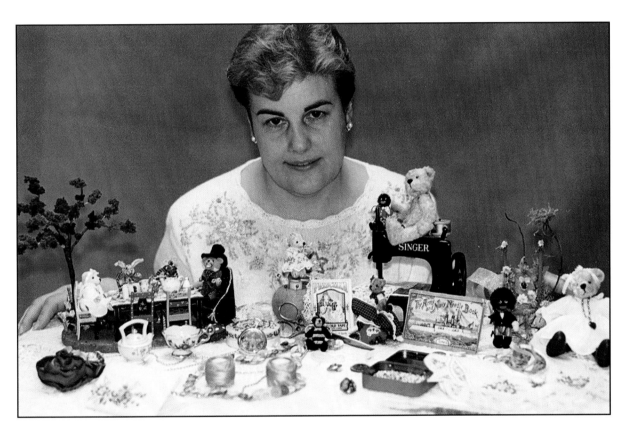

Illustration 140. Debby Hodgson.

Joan Links
Bear Links and Company
Ontario, Canada

I am a restless designer who is constantly tinkering with patterns or trying new techniques. I retire patterns very quickly. I never try to reproduce one animal to be exactly like another. Even the animals in the open editions will have small changes, or even larger changes that make them unique. My inspiration derives from Steiff bears from the 1920s or rather than from the very early bears. I also collect Steiff bears and animals, most of them dated from the 1950s on. I also love artist animals and buy whatever I can afford. In 1995 I won the Merrythought Award at the Calgary Bear Fair. My bear was then reproduced by Merrythought in a limited edition of 250. The edition was sold out within two weeks of issue! I use dense mohair and alpaca fabric when designing the bear's face. The extra density makes a good surface for sculpting, airbrushing or painting a face. The sharp point on embroidery scissors allows me to get into very small spaces when sculpting a face, and the curve of that small tool makes it easier to cut in a grooved area without cutting the fur around it. I often hand-paint my bear with airbrush paint or acrylics. I test different paints on fur samples using brushes, sponges, rags and whatever I think may work to apply color. I also use spray bottles and stencils as an alternative to expensive airbrushes. Many of my construction and surface embellishment ideas come from sewing, dyeing, and painting ideas in quilt books.

Began selling retail: 1993
Price range: $125 (6in/15cm) - $325 (20in/51cm)
Approximate annual production:50
Approximate number of shows per year: 3-4

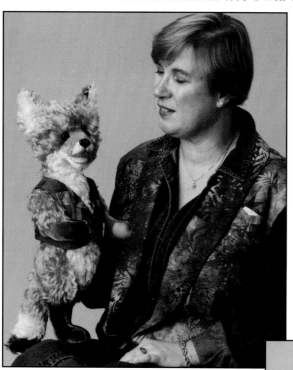

Illustration 141. Joan Links.

Illustration 142. (Back). *Acorn.* 1997. 19in (46cm); beige, green and blue green mohair; glass eyes; polyester fiberfill and pellet stuffing; fully jointed. Hand-painted details and needle sculpting on face; hand-dyed fur on body, open mouth. (Left) *Grasshopper.* 1997. 11-½in (29cm); three shades of green mohair (hand-dyed); glass eyes; reddish-brown stitched nose; polyester fiberfill and pellet stuffing; fully jointed. (Right) *Beech.* 1997. 8-½in (21cm); honey gold, light and dark green mohair; glass eyes; polyester fiberfill and polyester pellet stuffing; fully jointed; hand-painted details. *Photograph by Evelyn Newsome.*

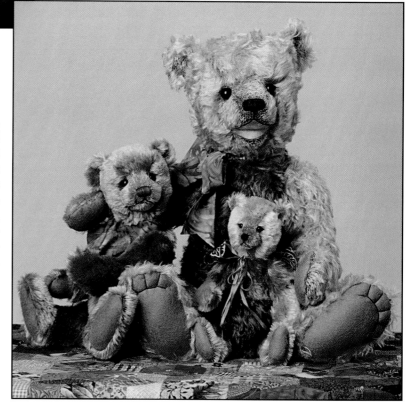

Susan & Mark McKay
Bears of the Abbey
Ontario, Canada

Our first professional show was in October 1991. It was an upscale craft show that introduced us to the art of standing and greeting people over a three day period. It almost killed us! I have always been a passionate collector of teddy bears. Mark's first bear was a Merrythought sent to him from England by his grandmother. He lives with us still and is very much cherished. Our collectors have come to expect a very diversified collection ranging from both traditional and antique designs to contemporary bears such as the "Great Bear Detective" series. Our "Bears in the Wild" series is an open edition due to the difficulty in craftsmanship. We want to give our collectors an equal opportunity to place orders without the constraint of production limitations.

We have some basic price parameters but there are other factors which influence our pricing such as finishing features, airbrushing, dyeing of fabrics, unique construction features, and antiquing. Mark launched a new show promotion in 1997 called "Teddy Bears on Vacation". We plan on developing four to five shows throughout Canada within the next five years.

Began selling retail: 1991
Price range: $165 (9in/23cm) - $350 (16in/41cm)
Approximate annual production: 350
Approximate number of shows per year: 16

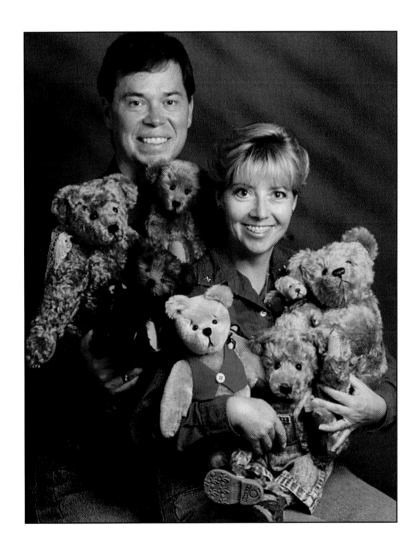

Illustration 143. Susan and Mark McKay.

Colleen (Merlin) McLaughlin &
Pauline Merlin
Bear Magic Canada
Ontario, Canada

We're the two "head bears" in the company. We have sharpened our skills by entering competitions. Many times we have benefited without even winning. As we went to shows, we talked with other artists who were very willing to share their knowledge. A note of warning: there is no reason to pick other artist's brains surreptitiously. Be honest and up front about the information or help you need. Always try to give the artists the courtesy of asking if they are willing to share or help; let them know you are interested in friendship in any event. Remember, open and friendly artists usually sell more bears. We believe this is one reason our skills have continued to grow since 1986. We make reproduction antique collector bears and also design some with a modern look. We have won best of show and placed first and second in various shows and conventions. Until recently we taught many workshops for local teddy bear stores. Our latest was for children in kindergarten and grade two. These were the most fun of all!

Began selling retail: 1986
Price range: $65 Canadian (6in/15cm) -
$350 Canadian (18in/46in)
Approximate annual production: 100-150
Approximate number of shows per year: 6

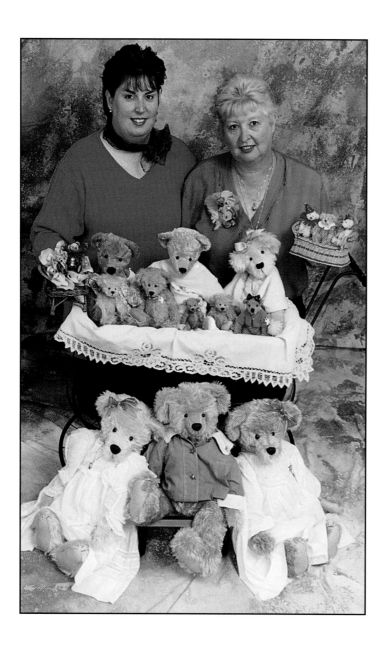

Illustration 144. Colleen (Merlin) McLaughlin (left) and Pauline Merlin (right) enjoy working together to create a wide variety of bears with sweet faces.

Wendy McTavish
McTavish Teddies
Ontario, Canada

My daughter Christine and I began making bears in 1985. We worked together until last year when she retired from bear making to devote her time to her four young boys. Our family has always been artistically inclined, so it was not a stretch to go from making toys and clothes for my four children to making jointed bears in a variety of sizes. I am constantly changing and adjusting my patterns. I was particularly thrilled when Dean's Toy company chose my polar bear to represent Canada for its 1996 Artist Showcase. I mainly make one-of-a-kind bears and sell them in local shows and a few select stores. At Christmas I hold an open house at my home.

Began selling retail: 1986
Price range: $90 Canadian (6in/15cm) -
$295 Canadian (24in/61cm)
Approximate annual production: 100
Approximate number of shows per year: 3

Illustration 145. Wendy McTavish.

Illustration 146. *Bear.* 1997. (15in (38cm); hand-dyed (honey colored) recycled mohair coat; plastic eyes; fully jointed. Cotton housecoat, bunny slippers made from recycled mohair coat. Little rabbit made from wool fabric.

Brenda Power

Brenda Power Miniature Bear Artist
Ontario, Canada

I have been fascinated with miniatures since childhood. I had a tiny tea set that was florescent pink and lime green plastic. The plates and saucers were no bigger than 1/2 inch (1cm). When I saw my first miniature artist bear I couldn't take my eyes off it! I also couldn't afford it; so I scaled down one of my full size patterns and made one of my own. I soon realized why they were so expensive. My first miniature bears looked like antiques. I liked long arms, long noses and the traditional hump. All of them are fully jointed with discs and cotter pins. Recently my bears are more whimsical and many have shaved snouts. Because of their proportions, it is impossible to look at a picture of my bears and tell that they are miniatures. They look like full size mohair bears. Some of my most popular designs are miniature working toys. They include a rabbit that hops when pulled, a duck, a goose and a penguin that have leather feet and walk when pushed.

Began selling retail: 1995
Price range: $90 (2-¼in/6 cm) -
$110 (3-¼/10cm); One-of-a-kind,
limited editions up to $275
Approximate annual production: 75
Approximate number of shows per year: 6

Illustration 147. Brenda Power.

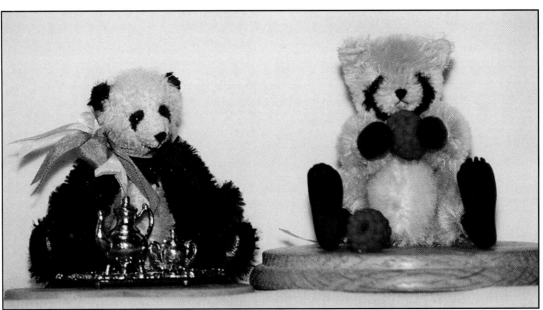

Illustration 148. (Left). *Mai Ling's Tea Party.* 1997. 2-¾in (7cm); black and white semi-distressed mohair; glass bead eyes; fully jointed. (Right) *Rascal.* 1997. 2-¾in (7cm); ash white and black mohair; hand-painted tail; glass bead eyes; paws are sculpted from Promat; fully jointed; wire armature in arms and legs. *Rascal* holds a raspberry in his paws. Limited edition of 10.

John Renpenning
Johnny Bears
Alberta, Canada

I was working as a draftsman and making bears in my spare time when I was commissioned to make a limited edition of 75 bears, which were given to participating artists at Calgary's first Annual Bear Fair held in November of 1993. This taught me "Artist's Discipline" and helped develop my skills. I was grateful for the opportunity but concentrating on producing 75 of the same bear in my spare time leaves something to be desired. However, a new career was born! In 1994 I started working full-time in a teddy bear shop in Calgary, "2 Bears Teddy Bears," owned by my mother and me. I enjoy designing making character bears with an appealing, fine-featured head and untraditional limbs, incorporating flow-ing curves into the design. I have been greatly influenced by the work of Ted Menten who has also taught and provided me with a great deal of encouragement. I learned bear making in a workshop taught by my father. In September, 1994 I took over those workshops from my father and presently teach Beginner and Advanced Designing workshops on a regular basis. By teaching and listening to the desires and suggestions of other bear makers, my perspective has been broadened substantially. My goal is to continue to make quality teddy bears, not quantity, and branch out to other animals as well as improving on my teaching skills so that other aspiring artists may benefit from my knowledge.

Began selling retail: 1994
Price range: $175 (10in/25cm) - $800 (24in/61cm)
Approximate annual production: 200
Approximate number of shows per year: 4

Illustration 149. John Renpenning.

Illustration 150. *Dweezil.* 1997. 24in (61cm); copper colored mohair; glass eyes; fully jointed. Wearing a silk bow tie, black and white check jacket; and hand-carved walking stick. Limited edition of 5.

Ingrid Norgaard Schmid
Bears N' Company
Ontario, Canada

Before bears I worked with an artist in Switzerland creating a Swiss doll. I wanted a bear for the dolls and found none in the size, quality or style suitable for this type of doll. I researched antique bears of days gone by, scoured antique markets for fabrics and accessories, experimented with patterns and eventually found a style I was happy with. I only create dolls selectively today, most often when they become part of a "bear story." My most popular designs are long-legged, Victorian vintage-appearing bears dressed as children of the past with leather shoes (enabling them to stand freely), dresses, sweater, scarves and mittens with head bows. This look developed from an old photograph of my mother as a little girl. I consider presentation of my bears an important part of marketing. This I achieve by creating an atmosphere through my display unique in its entirety.

Began selling retail: 1990
Price range: $75 (6in/15cm) - $300 (20in/51cm)
Approximate annual production: 250
Approximate number of shows per year: 6

Illustration 151. Ingrid Norgaard Schmid.

Illustration 152. (Left). *Mona* 12-½in (32cm). (Right) *Lisa* 9in (23cm). 1997. Antique gold distressed mohair; German hand-blown glass eyes; plastic pellet and polyester fiberfill stuffing; fully jointed. Tutu designed and sewn from a silk vintage bathrobe overlayed with embroidered lace and netting. Leather shoes with embroidered bow and silk ties. Dried floral wreath with chiffon and silk tie accents. Victorian gold heart necklace. *Photograph by Rex Glacer.*

Joan C. Stevenson
Wildlife Originals
British Columbia, Canada

Twenty years ago, a bin of fake fur scraps caught my imagination. I had to do something with them. Cartoony rabbits, cats and hedgehogs changed to more realistic Canadian wildlife and eventually bears emerged as <u>the</u> mammal. The more I learned about bears, the more I made. I do not make "teddy bears" in the traditional way. Frankly, I don't know how. I try to recreate nature. I make all bears, polar, grizzly, panda and koala. However, requests for the *Black Bear Cub* have doubled, then tripled and it has become my bread and butter. I'm quite lazy. I want as few pattern pieces as possible, so I do a fair amount of gathering...and I don't put in a lot of gussets and things. It might be easier if I did since it would cut down on the amount of hand-sewing, of pulling with long needles to get the shaping I want to emphasize muscles and expressions. Every animal is made from synthetic fabrics with knitted backing which makes them far more flexible than a firmly stuffed mohair bear. People seem to react to my creations as if they are real and hold them like a pet rather than a toy.

Began selling retail: 1988
Price range: $500 (16in/41cm) -
$1,000+ (36in/91cm)
Approximate annual production: 10
Approximate number of shows per year: 0

Illustration 153. Joan C. Stevenson.

Illustration 154. *Black Bear Cub.* 1997. 30in (76cm); black tipped brown synthetic fur; brown suede behind clear plastic eyes; ultrasuede (shaded with dye) paw pads; unjointed; stuffed cloth tube as backbone. *Photograph by Carolyn Paver.*

Danish Teddy Bear Artist

Maj-Britt Lyngby

Majse Bear
Ausgarde, Denmark

My friend, Grete Olesen got me interested in making teddy bears. As a collector of both antique and artist bears, one of my greatest hopes to be a well-known bear artist.

Began selling retail: 1993
Price range: $65 (2 in/6 cm) - $200 (24 in/60cm)
Approximate annual production: 80-100
Approximate number of shows per year: 2-3

Illustration 155. Maj-Britt Lyngby.

CHAPTER NINE

Dutch Teddy Bear Artists

Yvonne Plakké:

Making teddy bears in Holland.

Artist teddy bears are very popular here in The Netherlands. There have been other manias such as geese, chickens, pigs and frogs. But, bears are different. They will stay forever.

Dutch people, by the way, are very plain and sober. Teddy bears are just a natural part of their lives and their houses. Even though they are raised with teddies, they are a bit ashamed that they collect teddy bears.

Only a small percentage work full-time in bears (around 10%). In Holland, it is very difficult to earn a living in a business with completely hand-made products. We are a very small country and that means that artists need to travel a lot to shows in Europe and even further. This is very time consuming and expensive.

Since the bear-mania has started, the market for materials and supplies automatically grew. We have two teddy bear clubs and one club exclusively for miniatures. The number of shows has also grown and every weekend there are at least two or three smaller shows from which to choose. There are at least three large, established shows which are The Amerongen Castle Fair, De Doelen Eastern Fair and AHOY.

Tim Bos
Bos Beren
Amsterdam, The Netherlands

I started making bears with my girlfriend, Frederike, after we had visited a Teddy Bear fair. At first I said that making teddy bears is not for a man. Sewing bears is for girls and not for boys. But, after my first bear, I could not stop making them. After my second I was using my own design because I wasn't satisfied with the pattern I'd bought. My bears are all character bears, they usually have a little bit of a "sad" look and maybe that's why everybody likes them. My basic education is in hotel management and cooking. Cooking is still my hobby. In 1994 I made a bear for a contest called "Bears in Professions." I made a little cook's aide. Even though I didn't win a prize, my bear traveled through many different countries such as England, Germany, Holland and Belgium. My bears are identified with a little wooden logo handmade with a figure saw. I put the logo with a little stamp on the wood. The bear is a design which really exists. I am very attached to him. His name is *Slappie*. He's too thin to stand or sit because I ran out of stuffing material on vacation and didn't have enough for him! Frederike and I collect contemporary bears of different kinds of artists. We just bought an old French farmhouse to restore; maybe we'll start a little restaurant there with an atelier where I can sell my bears and paintings.

Began selling retail: 1996
Price range:$60 (4in/10cm) -
$300 (23-½in/60cm)
Approximate annual production: 40
Approximate number of shows per year: 4

Illustration 156. Tim Bos.

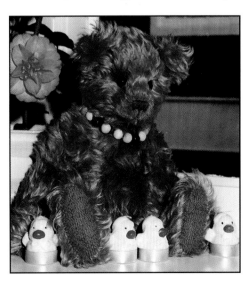

Illustration 157. *Freddie.* 1997. 15in (38cm); reddish brown mohair; shaved mohair paw pads; fully jointed. One-of-a-kind.

99

Marjan Jorritsma-de Graaf

Tonni Bears
Gieten, The Netherlands

Bear making is my full time job. Tonni bears is named for my brother who passed away ten years ago. He was my best friend. Giving my bears the name Tonni feels good and as if my brother is still around. For many years I was a doll maker who loved bears. In 1993 Joan Woessner came to Holland to do a class and my husband, Reinder, encouraged me to participate. In 1994 my husband and I started to make our own teddy bears. Mostly, I create the old look bears with dark hands and feet. They have long noses and old eyes. Some even have holes in their feet, just like real old teddies! I am in demand because I have won a number of prizes in the Dutch Championship, Open European Championship and the European Championship. Tonni bears are sold the world over in Germany, Singapore, America, Austria, Switzerland and Japan.

Began selling retail: 1994
Price range:$130 (2-1/2in/6cm) -
$500 (19-½in/50cm)
Approximate annual production: 300
Approximate number of shows per year: 5-6

Illustration 158. Marjan Jorritsma-de-Graaf.

Illustration 159. (Left). *Browny.* 20in (51cm); brown mohair; glass eyes; polyester fiberfill and pellet stuffing; fully jointed. (Center) *Mini Bear* 3in (8cm); beige upholstery fabric; glass eyes; polyester fiberfill stuffing; fully jointed. (Right) *Sweetheart* 20in (51cm); off-white mohair; glass eyes; polyester fiberfill and pellet stuffing; fully jointed. All bears produced in 1995.

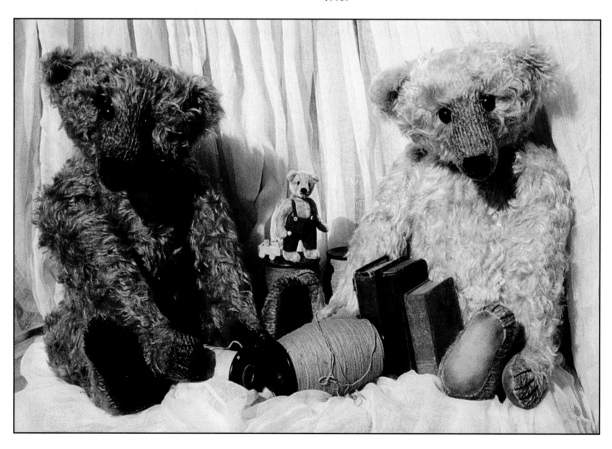

Tineke Oostveen
Bear in Mind
Vlaardingen, The Netherlands

It all started as an experiment. At first I made fantasy figures in the form of puppets and dolls. But I noticed there were a lot of bear artists present. I wondered if I could do this too; and now I do. Most of the bears are one-of-a-kind. However, there is one popular open edition called *Bearly Friend*; these have double-jointed necks. Like all my bears, they are never dressed. But these in particular have a natural look because of the neck structure. Because I enjoy the creative process so much, I keep different sizes of joints and eyes in stock, so that when a new idea occurs I can be able to work it out!

Began selling retail: 1993
Price range: $70 (6 in/15cm) -
$350 (25-½in/65cm)
Approximate annual production: 150
Approximate number of shows per year: 12-20

Illustration 160. Tineke Oostveen.

Judith Schnog
Itchy's Den
Apeldoorn, The Netherlands

I have a tendency to create natural bears. But, then, they are quite comical too. For instance, I make a "real" polar bear who is ice skating. Another popular creation is my fishing friends with their bamboo fishing rods. They manage to get into all sorts of trouble! My seventh design, *Itchy*, was my first competitive attempt. I had been making bears for about ten months at that time and he won me a first prize in the novice category at Beer Bericht Wedstrijd Scheveningen (1995). I am very active on the Internet and have a Website. On the Internet I am known as Schnoggy.

Began selling retail: 1995
Price range: $100 (1in/3cm) -
$180 (3-½in/9cm)
Approximate annual production: 75
Approximate number of shows per year: 4-6

Illustration 161. Judith Schnog.

Illustration 162. *Momigotwan.* 1997. 3in (7-½cm) long; 2in (5cm) high; medium brown long-pile upholstery fabric; onyx bead eyes; open mouth; mohair stuffing; fully jointed. Depicts a young bear catching his first fish.

102

Paula Tinga
Paula Tinga Originals
Den Haag, The Netherlands

My bears have a romantic appearance with sweet, innocent looks; big humps, long snouts, small ears and, if at all possible, dressed up in antique outfits. Being involved in the bear world has brought me many friends. This was an unexpected aspect of bear making that I had no idea about when I began. Of course, I have to write more and more Christmas cards each year.

Began selling retail: 1996
Price range: $100 (15 in/38cm) -
$400 (24in/61cm)
Approximate annual production: 150-200
Approximate number of shows per year: 8

Illustration 163. Paula Tinga.

Illustration 164. (Left to right). *Paddy* 15in (38cm); brown English mohair; old shoe-button eyes; polyester fiberfill pellets and wood wool stuffing; fully jointed. *Henderson* 1997. 22in (56cm); beige German mohair; old shoe-button eyes; polyester fiberfill and pellet stuffing; fully jointed. *Bubba* 15in (38cm); brown English mohair; old shoe-button eyes; polyester fiberfill, pellets and wood wool stuffing; fully jointed.

Richard van Aalst
Richland Bears
Nieuwegein, The Netherlands

I make just teddy bears, in a small size. They are old looking and partly filled with wood wool and then loosely jointed to give them a special look. I prefer making one-of-a-kinds. My limited editions are five or ten. But they are all slightly different. My most popular bear was *Stef* made of long pile upholstery fabric with a wobbly head. I made him in an edition of 25 in different colors with some small accessories like jackets or sweaters. There was another one called *Anton* who was made of mohair. He was just 3in (8cm) but he made a big hit. People still ask about him and I regret I had limited him to only ten. I do several fairs a year: two in Holland; two in London; one in Germany and one in America.

Began selling retail: 1994
Price range: $110 (2in/5cm) - $120 (3in/8cm
Approximate annual production: 300
Approximate number of shows per year: 6

Illustration 165. Richard van Aalst.

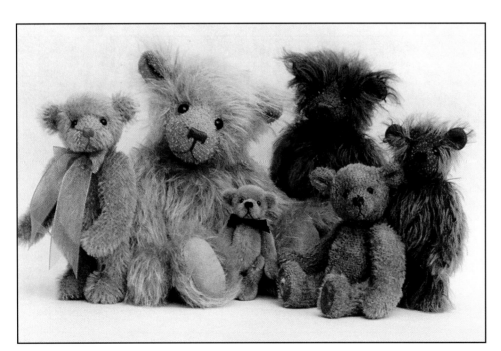

Illustration 166. (Left to right). *Bear* 4in (10cm); gold-yellow mohair; glass eyes; fully jointed. Organza bow. *Warren* 7in (18cm); beige yellow mohair; glass eyes; polyester fiberfill and glass bead stuffing; first larger size bear produced. *Thomas* 2-1/3in (6cm). Gray English plush; onyx eyes; arms and legs thread jointed; head jointed with cotter pin. *G.I.* 4in (10cm); green mohair; glass eyes; fully jointed. Limited edition of 5. *Shima* 4in (10cm); yellow mohair; glass eyes; polyester fiberfill and wood wool stuffing. Old-looking bear. *Scruffy* 2-½in (9cm); sparse brown mohair dark brown backing; glass eyes; fully jointed. All bears produced in 1997.

Sylvia van Otterloo
SylBears
Hellevoetsluis, The Netherlands

For 25 years, my husband and I have made harpsichords. I do the fine woodworking and decorating. Prior to that I was a gold and silver jewelry maker and restored and decorated furniture. My new endeavor started with buying myself a teddy bear in England. That's when I discovered the teddy world. Sometimes teddy bear making can be a lonely profession, but I derive great pleasure when collectors choose one of my bears. I enjoy producing classic bears representing historical persons like *Erasmus*, and *Queen Wilhelmina der Nederlanden*. Perhaps my best-known creation is *Liberation Bear* chosen by the Dutch Teddy Bear Club in 1995.

Began selling retail: 1991
Price range: $60 (5-¾in/15cm) -
$300 (27-½in/70cm)
Approximate annual production: 120
Approximate number of shows per year: 5-6

Illustration 167. Sylvia van Otterloo.

Illustration 168. *Something New(s)?* 1996/97. 14in (36cm); black mohair; body is made from *London Times* printed on cotton; shoe-button eyes; leather paw pads; head stuffed with kapok, body with cotton. Made for European Teddybear Contest. Category concept was to make a bear after the word "News." Won the Innovation prize, 1996.

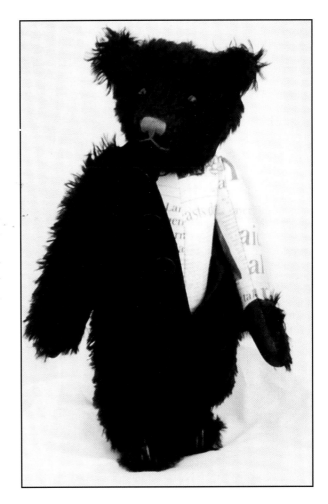

Gerda van't Veer

PoeBè Miniatures
Huissen, The Netherlands

When I attended my first teddy bear show I saw miniature bears made by Deb Canham and Louise Peers. I liked them so much that I wanted to make miniature bears too. Once I got the pattern in a magazine there was no stopping me. Today I make both bears for sale as well as kits of my own designs. I have one bear who is particularly popular. His name is *Humpy*. He looks up trying to smell what he sees up in a tree. He was first designed standing under an apple tree, longing for one of those nice apples. One apple fell, but it had a worm. His whole body lan-

guage expresses his need for someone to give him some help, getting another apple. Besides *Humpy*, my *Flowerbearries* are also fairly popular. I am drawn to bears with sweet faces and lots of character and details. I like to collect bears too, most specially miniature bears by bear artists.

Began selling retail: 1995
Price range: $95 (2in/5cm) -
$200 (3-½in/9cm)
Approximate annual production: 150
Approximate number of shows per year: 6-8

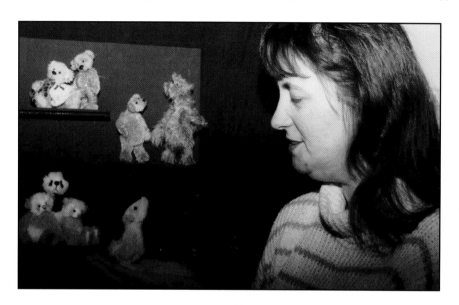

Illustration 169. Gerda van't Veer.

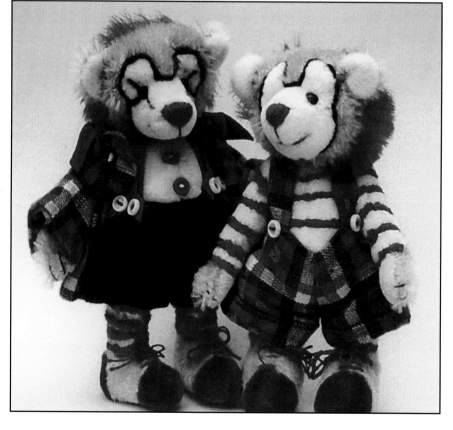

Illustration 170. (Left) *Hendrico.* (Right) *Keppely.* 1997. 3-½in (9cm); white/yellow/red mohair and cashmere; antique glass bead eyes; cotton stuffing; fully jointed. Completely hand-stitched.

CHAPTER TEN

French Teddy Bear Artists

Marylou Jonet:

A teddy bear artist from France shares her view.

There are very few teddy bear artists in my country. A couple of them make bears part time. Maybe there are more who make bears for a hobby. Most people in France think that bears are only for babies. I am one of the few who designs and makes contemporary bears. I've even started to dress my teddy bears, which is quite unusual here. It is extremely difficult to get materials. In fact, most of us travel to England and/or Germany for mohair and glass eyes. And my personal bear information comes from subscriptions to foreign magazines such as *Teddy Bear Review* and *Teddy Bear and Friends*. We are newcomers on the international bear scene. Just recently, for the very first time, a special newspaper for toys did a big article on teddy bear artists. So, the scene is slightly changing for the better.

We do have one teddy bear club and a brand new small publication. Even our shows are not for bears alone. We are pleased that there are two museum exhibitions that display bears and there is one show, "Paris Creation" for miniatures, dolls, and bears.

107

Héléne Bastien
Héléne Ours
Perrusson, France

It is difficult for me to share about my artistry. I am a new artist who doesn't speak English. I dream that someday I may make my living from my bears and to travel to teddy bear shows abroad. Presently I make eight different sizes and 20 different bear designs. They are classically designed with a little nostal-gia. I use old lace, materials and ribbons. Each bear comes with a certificate (with a photo of me as a little girl, the name of the bear, materials used and the inscription: I'm not a toy!).

Began selling retail: 1996
Price range: $115 (8in/20cm) - $399 (19in/48cm)
Approximate annual production: 70
Approximate number of shows per year: 4

Illustration 171. Héléne Bastien.

Illustration 172. *Nagawyka.* 1997. 14in (36cm); sparse long caramel colored German mohair; German black glass eyes; fully jointed. Héléne's interest in Native Americans inspired this creation. Limited edition of 5.

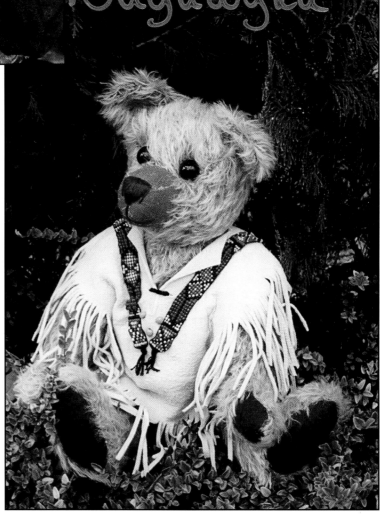

Anne-Marie La Marca

La Marca Anne-Marie
Marseille, France

I have had a horrible reoccurring dream of a giant bear chasing me down a steep slope. There was a forest and I could not disappear because I was too afraid to move. I did not now how to run away. I never knew the end, because I always woke up with a start. To my great relief, after I made my first bear I have had a feeling of great calm and my dream has disappeared. One day I came across the French version of *The Ultimate Teddy Bear Book* by Pauline Cockrill. I knew this is what I was meant to do as a job! So I taught myself by observing the photos in the book. Unfortunately, in France, nothing exists for making bears. I am forced to buy all my materials from foreign countries by mail order. I order from as far away as California and New Jersey. I also buy materials from England and Germany. I am the only artist of this sort in Marseilles. And, the only way to purchase my bears is directly through me! Each is guaranteed to be a unique piece. I do not ever duplicate a bear. In fact, I automatically destroy each pattern after sewing. If I crochet, I need no pattern. It is all in my mind. I use all kinds of different techniques and styles. For each bear, it takes me from ten to 30 days, according to size and difficulty. If dressed, if clothes are an integral part of the bear, if there are accessories and if the joints are entirely handmade it takes even longer. The first international contest for me was in conjunction with the Nagano Olympics in Japan. My exclusive design for entry was *Oreilles Anneaux* (Rings Ears). Since I am so isolated here, I am glad to share any bear making tips or other information related to general sewing. Write me your questions, and I'll be happy to respond! (See address at end of book).

Began selling retail: 1995
Price range: $200 - up
Approximate annual production: 15
Approximate number of shows per year: 0

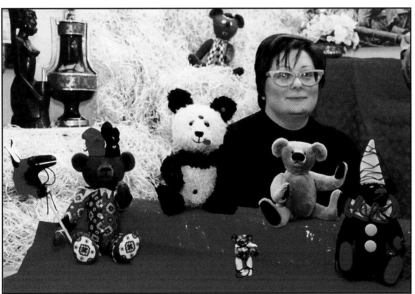

Illustration 173. Anne-Marie La Marca.

Illustration 174. *Victor "Le Téméraire" (Victor "The Foolhardy").* 1997. 14-½in (37cm); French black flannelette sailor suit an integral part of body; head and paws, of French golden honey shiny carpet material; German black glass eyes; fine French excelsior stuffing; fully jointed. *Photograph by Nino La Marca*

I reside permanently in France, but was educated in California. I am the third generation woman artist with a university degree in my family. I count among my various accomplishments in the bear world having bears in permanent collections of the Museum of Decorative Arts , Paris (The Louvre); Museum of Dolls, Chateau de Joselin; Museum of Dolls, Paris; Museum of Natural History, Paris. I have not yet entered a bear in a contest. Maybe they don't appeal to the mass market. My bears have powerful expressions and tiny eyes close together. I also have a thriving business in dancing chickens, sheep and cows (no joke) made out of papier-mache. I would like to continue what I'm doing, but spend even more time on ears and less time with my hands in the glue! Another sideline of mine is producing cards of my work. I have professional photos taken of my work and order reprints in large numbers. Then I fold white Bristol paper, glue the photo on and stamp my name and address on the back. Each finished card is slipped into a plastic protector. I provide corresponding envelopes, ordered 500 at a time. Eventually, I make my costs back and every card is sold (or even given away). By definition that card was chosen by someone who likes my work, and thus, put to whatever use, doing me good. I am not afraid of people obtaining images in order to copy my work. As an artist-creator, they can't copy what I'm capable of producing tomorrow!

Began selling retail: 1988
Price range: vary (4 in/10cm) - (28in/73cm)
Approximate annual production: 50
Approximate number of shows per year: 1-2

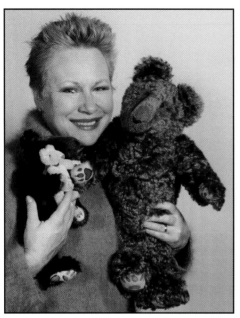

Illustration 175. Susan Tantlinger.

Illustration 176. (Left to right) *Eugene #48, Emile #71.* 1997. 16in (41cm); cashmere and wool; German glass eyes; individually painted felt paw pads; polyester fiberfill stuffing; fully jointed.

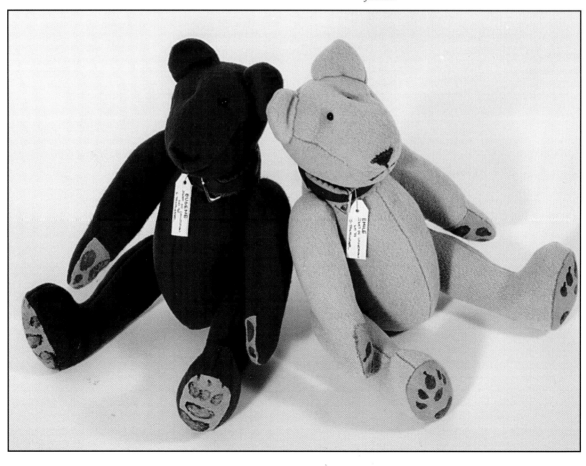

Laurence Veron
Paris, France

France is not a bear country. We have a few specialized shops, few artists, and teddy bear magazines don't exist. Fortunately, there is a teddy bear club, called the *Club des Amis de L 'Ours* (Bear Friends Club). I also created my own small journal called *Oursement Votre* (Bearly Yours). I write it all by myself, including stories for children or adults, articles about toy shows and artists. Sometimes, a reader or a pen pal sends me an article and a photo which I include. I began making bears after losing my job as a fashion designer. My first bears were not very nice since I tried to make the patterns all by myself. I used only synthetic fur or cotton and made bears for children. Then, I met a toy manufacturer and they advised me to make old style bears with beautiful materials. Now my bears have long muzzles, jointed arms and legs. I try to find new materials, looking old and sweet, and I also like to work with colors, especially red or pink. Becoming a full time artist is very difficult in France, as the contemporary bear market is not large. Most of us have another job. The best way to sell bears here is to display work in the toy shows. I've found Paris-Creation the best for artists' bears, but had to register almost a year before the show.

Began selling retail: 1995
Price range: $30 (2in/5cm) - $100 (11-½in/30cm)
Approximate annual production: 100
Approximate number of shows per year: 2

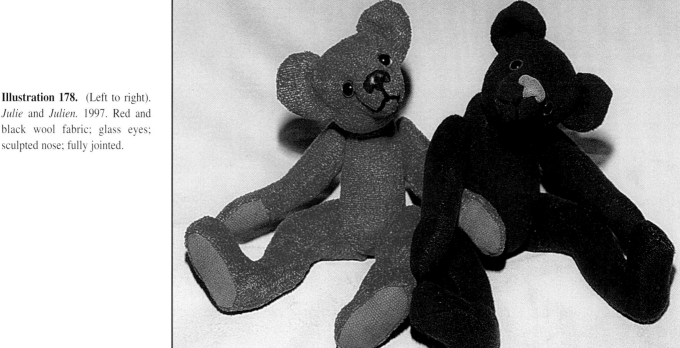

Illustration 177. Laurence Veron.

Illustration 178. (Left to right). *Julie* and *Julien*. 1997. Red and black wool fabric; glass eyes; sculpted nose; fully jointed.

German Teddy Bear Artists

Verena Greene-Christ

<u>The tradition of German bear artistry.</u>

Germany has a long history of making teddy bears. Germany is also where teddy bear artists have gained national and international admiration within the last few years. The teddy bear artist market started about eight or ten years ago. My mother Vera Moller and I, along with other bear artists, were among the first to attend a few doll shows with our bears. Shortly after, the first teddy bear shows were offered, magazines appeared and collectors were happy to find unusual teddy bears other than produced by large companies.

Those original artists are still active and their ideas have matured into small businesses expanding even to foreign countries. The average age of our bear makers and artists are young women in their twenties and thirties, but men are also getting involved and there are some outstanding male artists in our teddy bear community.

Germany has a rich history of mohair weavers, glass blowers and makers of growlers, as well as other goods needed for bear making. The regular artist teddy bear is made from fine German or English mohair and many of these artists have taken their bear making further than just an avocation.

The seasons of spring and fall include a huge amount of shows, shop signings, fairs and markets. In order to be competitive, bear makers must work harder on all aspects of their craft.

I was lucky to experience the growth of the German artist teddy bears from the inception, to see new artists appear and to feel the energy of new ideas around me. A teddy bear is one of the few items where old and young, male and female, unite. To see the sparks in the eyes of teddy bear lovers when they see a new bear is still my biggest joy in life.

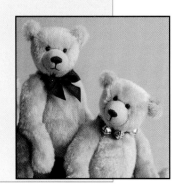

"Bärfidel"
Schwaigern, Germany

When I began to sell my bears in Germany, all collectors wanted to buy Steiff Bears. They said mine were really nice, but there is no button in the ear! A few times I really wanted to give up. After I read Tolkien's *The Lord of the Rings*, I began to dress some of my bears like fantasy figures. I have won some awards for these fantasy bears (for instance, 1996 Golden George, for my classic bear *Gandalf*, dressed as Papageno from the opera *Magic Flute*) and for classic teddies (1995, Creativa Teddy Award). Perhaps my most popular bear is of average size (13-½in/35cm). He's finished only with a piece of silk, a bell around the neck or something very simple. Another favorite is my classic bears, dressed in clothes made from feathers, leather and leaves of silk. All in all, I do ten different types of bears in 15 sizes.

Began selling retail: 1990
Price range:$134-undressed (9-½in/24cm) —
$900-dressed (27-½in/70cm)
Approximate annual production: 300-350
Approximate number of shows per year: 3-4

Illustration 179. Birgit Diedrich-Drobny.

Illustration 180. *Hickory.* 1997. 15in (38cm); beige mohair; black glass eyes; fully jointed. Outfit made of leather trimmed with feathers and wooden beads. One-of-a-kind.

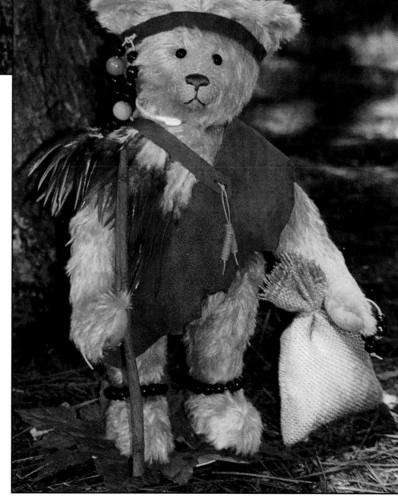

Susanne Grosser
Ursa Minor
Münich, Germany

My catalog shows 54 different types of bears in different sizes; but I make more than that. Some are one-of-a-kind for special customers, but mostly they are limited editions of seven or ten with a maximum of 25 pieces. A certain percentage of my bears are sold in exclusive teddy or doll shops in Austria, Switzerland and Germany. However, the other ones I sell by myself on direct order, when I get an inquiry. Then I send pictures and a price list to the prospect and then the collector can order what they want. Perhaps the most well-known is my panda bear *Ying-Ying*. Another favorite is a bear sitting in a pumpkin costume made from felt with leaves and blossoms.

Began selling retail: 1990
Price range: $145 (3in/8cm) - $233 (7in/18cm)
Approximate annual production: 80-100
Approximate number of shows per year: 5-6

Illustration 181. Susanne Grosser.

Illustration 182. (Left) *Hänschen.* 1997. 4in (10cm); light green and beige (tummy, inserted muzzle and inner ear); black onyx bead eyes; lamb's wool stuffing; fully jointed. Limited edition of 5. (Center) *John Foggan.* (Right) *Mischa.* 1997. 4in (10cm); beige long pile upholstery velvet; cream ultrasuede inserted muzzle; black onyx bead eyes; lambs wool stuffing; fully jointed.

My work is predominantly one-of-a-kind and limited editions of classic bears with sparse mohair and wobbly heads; occasionally I make other creations with jointed arms and legs as well as standing bears. My bears are beige and brown with very little clothing. Sometimes they wear a shirt or a pair of pants. I have never entered any competitions; so, therefore I have won no awards. Four times a year I teach a workshop here at my home. I use both my own patterns and craft kits. I truly enjoy creating new patterns and forms, which are evolving into my very own style.

Began selling retail: 1995
Price range: $100 (5-1/2in/14cm) -
$450 (31-1/2 in/80cm)
Approximate annual production: 200-220
Approximate number of shows per year: 12-15

Illustration 183. Christiane Kaufmann.

Illustration 184. *Fluppi.* 1997. 9in (23cm); yellow/beige mohair; black glass eyes; sheep's wool and plastic granulate stuffing; fully jointed (Loc-line®); wobbly head; free standing.

Ingeborg Taivassalo-Lutz
Teddybären-Atelier
Lörrach, Germany

My time is split between living in Finland and Germany. I teach many classes at university extension schools, privately and in workshops in both Germany and Finland. My studio is in the Finnish wilderness, where I get a lot of material used to produce my natural looking teddy bears. I collect blueberries, cranberries, birch and alder barks, moss and seaweed. In front of the sauna, these materials are mixed and cooked in a big pot to dye and change the mohair's appearance into a wild look. After that, the material is cut and sewn. The bears are stuffed with spruce-wood wool, birch-tree sawdust, lamb's wool and lavender. The growl voices are made only from natural material, too (no plastic) and the eyes are hand-made in a glazier's workshop in Thüringen, Germany. The patterns are either older than 50 years, or my own creation. Each teddy is a unique object. I never make a bear twice. My inspiration derives from Russian tales and the times I spent in Finnish Lapland.

Began selling retail: 1994
Price range: $80 (6in/17cm)
Approximate annual production: 80-100
Approximate number of shows per year: 10

Illustration 185. Ingeborg Taivassalo-Lutz.

Illustration 186. *Rosamunde Lapikainen.* 1997. 20in (50cm); golden, light brown old sparse mohair; dyed with alder bark; original shoe-button eyes; alder tree wool stuffing; fully jointed. Old scarf from antique market; little bear is *Dimitri*, a 4in (10cm) patchwork mohair bear.

116

Werner Pyschny
Bear by Bear (PW-Bears®)
Dortmund, Germany

My mother inspired me to make bears. After World War II she made teddy bears to get some money and food for our family. I helped her with sewing and stuffing. Prior to making bears, I painted, made dolls and restored antique furniture. This is a family business. My wife, daughter and two sons help me in production. The distribution is in the hands of "Bear by Bear" which is run by Helga and Manfred Schepp. I like to make teddies, but not to think too much about marketing. My bears show a touch of real old and loved teddy bears. I am often asked how I get the distinctive "antique treatment"...this is a family secret. To protect bears in the "Nostalgic Collection" we identify each with a small metal plate. These bears are sold in selected shops around the world.

Began selling retail: 1990
Price range: $200 (4 in/10cm) -
$5,000 (46in/150cm) with mechanical mechanism
Approximate annual production: 1200
Approximate number of shows per year: 1 (Werner only attends Teddybär Total in person)

Illustration 187. Werner Pyschny.

Illustration 188. (Left). *Clown.* 1997. 18in (46cm); light blue and royal blue mohair; glass eyes; linen paw pads; excelsior stuffing; fully jointed. One-of-a-kind. (Center) *Clown.* 1997. 9in (23cm); gold mohair; glass eyes; linen paw pads; excelsior stuffing; fully jointed. One-of-a-kind. (Right) *Clown.* 1997. 18in (46cm); blond mohair; glass eyes; linen paw pads; excelsior stuffing; fully jointed. One-of-a-kind.

Annette Rauch
Grossbreitenbach, Germany

Illustration 189.
Annette Rauch.

My hometown is near Thüringia, known for high quality handmade toys, glass articles, porcelain articles and so forth. I began my career as a certified skilled worker with toys in 1989 and afterwards studied at the Sonneberg School of Engineering for Toy Manufacturing. After the conclusion of my studies in 1992, I worked as a designer within the toy industry before going independent in 1994. My creatures look cheeky, obstinate, playful or lazy...they are always moveable and therefore changeable and so their general expression seems to be always alive. I make little clothing and accessories to achieve optimum expressions of form and character. I always worked alone, but lately I have two workers so I can quickly fulfil the customers' wishes. In 1995 I received a nomination for the TOBY Award and two gold medals for Eurodoll in Münich. A particular characteristic of my fabric creations is the registered leather bottom. Here you will find the figure's personal information: the name, year of manufacturer and production number; also, my personal symbol, an abstract mouse, which is a registered trademark.

Began selling retail: 1995
Price range: varies
Approximate annual production: varies
Approximate number of shows per year: varies

Illustration 190. *Ferdinand.* 1996. 9in (23cm); brownish yellow mohair in varying lengths; black glass eyes; velvet paw pads; sheep's wool and pellet stuffing; fully jointed. Made for Walt Disney World's® 1996 Teddy Bear Convention. Limited Edition of 25. *Photograph by Lutz Naumann.*

118

Kerstin Schibor
Schibor-Teddy
Tuttlingen, Germany

I live in Southern Germany near Lake Constance with my husband and son. I create miniature bears and sometimes bigger bears. Some of my bears are dressed, some stay naked and others are natural looking. I prefer to use mohair fabrics and sheep's wool filling. I have been honored with a number of prizes including "Meister Teddy 1997" awards for mini-bears dressed and undressed in Neustadt/Coburg Germany in 1997. I was also a nominated for a Golden George Award for miniature bears.

Began selling retail: 1994
Price range: $60 (small undressed) - $77 (larger)
Approximate annual production: 70
Approximate number of shows per year: 3-4

Illustration 191. Kerstin Schibor.

Illustration 192. Kerstin Schibor's precious miniature bear (sizes 3in-4in [8cm-10cm]) creations have found their way into the homes and hearts of collectors all over the world.

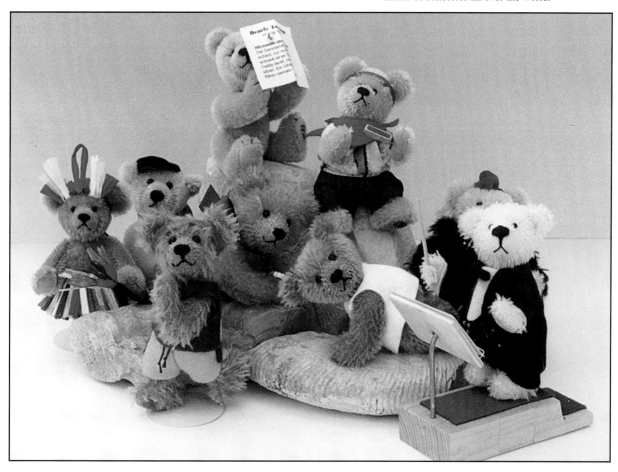

I was a teacher of arts and crafts for 12 years. After visiting the Nuremberg Toy Museum, a deep love for old toys grew in my heart. At that time I didn't realize how important this love would be in my future life. After a long time I took part in a seminar held by Ingrid Tillmann and a new world opened up to me. During one of the times I didn't want to mold doll heads, I began to design teddy bears. For about six months I made teddy bears using a classical pattern. Soon I was giving lessons in teddy bear design and sewing. Today I make both bears and dolls. My dolls express a yearning for love; my teddy bears contrast with the dolls; they are funny, playful and full of life. Thanks to their special design they are expressive and very poseable. All Schlotz bears have an extra swivel in their heads and body. My son, Christian, has surpassed me in the technical realm. Two years ago he presented a bear (*Bärllerina - Florentina*) with 11 joints who danced to a Gold Medal at the Eurodoll Fair in Munich.

Began selling retail: 1993
Price range: $80- Limited Edition (12in/31cm)
$200 - One of a kind (12in/31cm)
Approximate annual production: 300- 350
Approximate number of shows per year: 5-8
(Europe); 1 (USA)

Illustration 193. Gaby Schlotz.

Illustration 194. *Casar.* 1996. 14in (36cm); light brown mohair plush; black glass eyes; Kapok and pelts stuffing; fully jointed; extra joints behind the ears and elbows. Limited edition of 100.

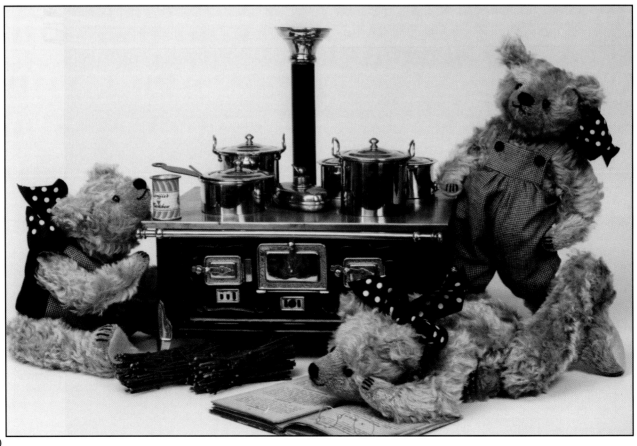

Bettina & Fredy Springweiler
FBS - Bär
Wolfsburg, Germany

There are two of us and we each produce our own one-of-a-kind or limited edition bears; each has a little bell on the belly. Sometimes we hold small workshops in our homes and we teach our students that it is better to create your own line of bears, rather than copy any other artists. But the most important concept is not to lose sight of the fun in bear making.

Began selling retail: 1996
Price range: $99 (4-½in/11cm) -
$250 (19-½in/50cm)
Approximate annual production: 250
Approximate number of shows per year: 12-15

Illustration 195. Bettina and Fredy Springweiler.

Illustration 196. (Left to right). *Langer Lulatsch* (18in [46cm]). *Blaues Paulchen* (10in [25cm]). *Langes Elend* (14in [36cm]); 1997. Blond and blue sparse German mohair and dark brown synthetic plush; black glass eyes; leather-like material paw pads; synthetic and sand stuffing; fully jointed.

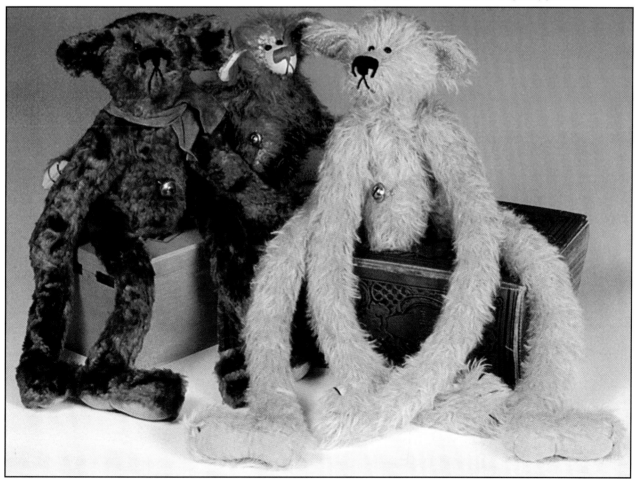

Claudia Wagner
Weini-Bären-Originale
Raunheim, Germany

After a friend of mine went to a workshop, she called me and said "let's make a teddy bear!" Since that time I cannot stop. I have no art background, but, since I am an optician by trade, it's very easy for me to see wrong set eyes and to measure small screws. At first I made bears with smiling faces and big eyes. Now I make traditional classical teddy bears. My "Barefoot Collection" is the most popular. I have won two Golden George prizes for miniature bears and a first place at the 1997 Pandamonium Convention. I have also received a Best Artist Bear Award in Baltimore in 1997. One of the ways I give back to the bear world is by teaching a pattern design workshop at well-known German Festivals. I've also taught bear making at conventions such as ILTBC.

Began selling retail: 1993
Price range: $140 (10in/25cm) - $270 (14in/36cm)
Approximate annual production: 200
Approximate number of shows per year: 10-13

Illustration 197. Claudia Wagner.

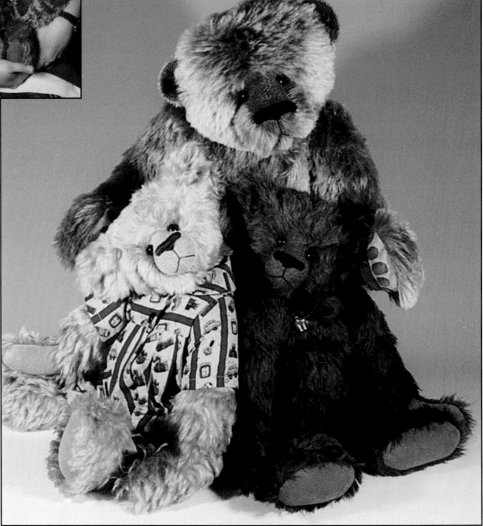

Illustration 198. The majority of Claudia Wagner's friendly-faced bears are made of high quality mohair.

Japanese Teddy Bear Artists

Ikuyo Kasuya:

A young pioneer in Japan's teddy bear world.

The popularity of teddy bears has grown remarkably in Japan in the past few years. About ten years ago, there was only one teddy bear shop in Japan, and it was almost impossible to obtain the materials or tools for bear making. Several years later, books on teddy bear making by hand began to become popular. Nowadays, we can find more than 30 books dealing with the subject; many teddy bear museums have opened; and many shops carry teddy bear materials and related items.

As teddy bears become more and more popular, the number of artists also increases. Most are around the age of 35. Mohair is used by 80 % of them, and half of them make dressed bears. But, still, there are only a few people who make their living as teddy bear artists.

There are six major teddy bear clubs or organization in Japan, and many small clubs, too. Teddy bear fairs are held four times a year. There is a great network of artists building in our country. Sometimes they visit a museum together or even attend overseas fairs together to exchange their knowledge and friendship.

I was greatly influenced by one of Beverly White's bears which was made as part of a trio of bears from *The Christmas Carol*. The bear's name was *Want*. She seemed about to cry and wanted to say something. I felt the spirit in this bear. However, it was not on sale. For two days, I went to see the bear time after time at Linda's Teddy Bear Show in San Diego. I took many pictures of *Want* and at the end of the show I went to say good bye. Beverly said "you can take her home with you. This is a gift." Then she kissed the bear and I understood that she also loved *Want*. This experience has stayed in my heart ever since. My dream is to make bears which will be loved in generations to come. Even when I go, I hope my bears will tell people of my heart and my feelings. I do not use a sewing machine at all. I make everything by hand and love.

Began selling retail: 1996
Price range: $180 (12in/30cm) - $350 (20in/50cm)
Approximate annual production: 100
Approximate number of shows per year: 4-5

Illustration 199. (Left) Miyuki Fukushima (Right) Kan Eto.

Illustration 200. (Left to right). *Put* (Baby). 1997. 13in (33cm); off-white mohair; glass eyes; polyester fiberfill and pellet stuffing; fully jointed. *Angels for you* (Mother). 1997. 17in (43cm); off-white mohair; German black glass eyes; polyester fiberfill stuffing; fully jointed (arms - flexlimb, legs - Loc-line®). *Put*. (Twin baby). 1997. 13in (33cm); off-white mohair; glass eyes; polyester fiberfill stuffing; fully jointed. This concept came from Miyuki's experience when she was five years old. She was hospitalized for a while and was waiting for her mother to visit. But her mother was a little late, and Miyuki got tired of waiting – then the nurse took her to the church which was built near the hospital. That was the first time she saw a beautiful stained glass. The church was filled with a very mysterious mood. In order to complete these bears, Miyuki added a handmade stained glass to express the beauty of life.

Momi Iwabuchi
Chiba, Japan

I was working on a display window exhibit when I met a teddy bear with whom I fell in love. My specialty is making a background and dressing the bear with clothes and accessories. When I am finished it all tells a story. Much of my advertising is through direct mail. My pieces reflect real bears in interesting settings.

Began selling retail: 1994
Price range: $80 (3in/8cm) - $700 (20in/50cm)
Approximate annual production: 50
Approximate number of shows per year: 2

Illustration 201. Momi Iwabuchi.

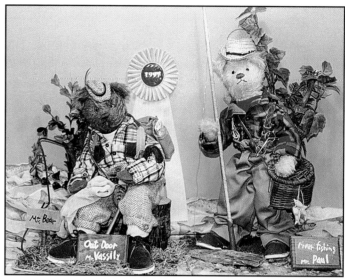

Illustration 202. (Left). *Outdoor. Mr. Vassily.* 1997. 17in (43cm); brown distressed mohair; green glass eyes; cotton stuffing; jointed arms and legs; unjointed head. Inspired by Momi's experience and love of working outdoors. (Right). *River Fishing. Mr. Paul.* 1997. 17in (43cm); gold distressed mohair; glass eyes; cotton stuffing; jointed arms and legs (Lock-Line® in arms); unjointed head. Inspired by the movie *The River Runs Through It.*

Emiko Kitagawa
Tokyo, Japan

I began by collecting *Muffy VanderBear* before I made a bear. After just one year of making bears for sale I won the Best of Show Award at Linda's Teddy Bear, Doll and Antique Toy Show and Sale (August 1996). Most of my bears are one-of-a-kind and some are limited editions of five to ten bears. You can tell them by their open mouths and the fact that they seem to tell a story. I want to use many kinds of fabrics, but usually incorporate the use of mohair or acrylic fur. I have discovered that a bear's appearance can be controlled by stuffing, but it is important to make a bear's shape with a paper pattern as much as possible.

Began selling retail: 1995
Price range: $160 (8in/20cm) - $390 (20in/50cm)
Approximate annual production: 50
Approximate number of shows per year: 2-3

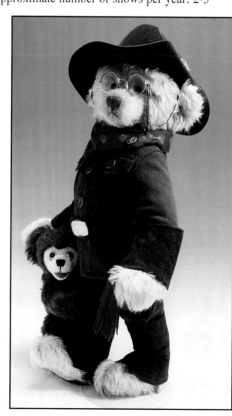

Illustration 203.
Emiko Kitagawa.

Illustration 204. *Roosevelt and Berryman Bear.* 1996. *Roosevelt* 20in (52cm); honey blond mohair; glass eyes; leather paw pads; Kapok, synthetic wool and pellet stuffing; fully jointed. Wool outfit. *Berryman Bear* 10in (25cm); dark brown mohair with short white mohair inset face; glass googlie-type eyes; fully jointed, one-of-a-kind. Piece won "Best of Show" at Linda Mullins' "Teddy for President" 1996 Artist Bear Competition in San Diego, California.

Yayoi Matsumae
Huggy Bears
Yokohama, Japan

I love every part of the bear making process. Making their faces is especially pleasurable, but at the same time it's the hardest task. I take a long time and extra care when it comes to making a face. Since my background is in dress making, I find particular delight in making dresses for my bears. I am fond of making little girl bears. All my bears are based on Victorian and Edwardian themes. I use upholstery velvet or hand cropped mohair for miniature bears. For larger ones, I use mohair fabrics. I have so many wishes for the future, but I hope to continue making bears for a long time; if my bears and I could do something for others it will be wonderful.

Began selling retail: 1994
Price range: $65 (1-½in/4cm) - $550 (20in/50cm)
Approximate annual production: 150
Approximate number of shows per year: 3-4

Illustration 205. Yayoi Matsumae.

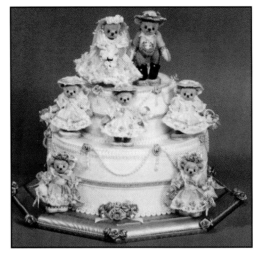

Illustration 206. *Dolce Vita.* 1997. 2in-3in (5cm-8cm); pale gold upholstery velvet; onyx bead eyes; ultrasuede paw pads; polyester fiberfill wadding stuffing; fully jointed. Sweet wedding cake decorated with bride, bridegroom, flower girls, and wedding guests. Exquisite outfits made of silk taffeta, French lace, silk ribbon, handmade silk roses, miniature glass beads. Handmade wedding cake shape display stand, hand-painted base, over 100 handmade roses decorate display. *Photograph by Ito Photo Studio.*

Fumiko Nose
Fumiko's Factory
Hyogo, Japan

When I make a bear, it's almost like the wonderful feeling that I had when I had a baby. When I was a schoolgirl, I learned to draw well and made preliminary sketches of Kimono as a part-time job. The tiny bears I make are cuddly and have a good sense of humor. I like to teach and twice a month hold workshops in the Kobe-Hankyu Department store.

Began selling retail: 1993
Price range: $38 (1-½in/4cm) - $100 (4-½in/12cm)
Approximate annual production: 50
Approximate number of shows per year: 4

Illustration 207. Fumiko Nose.

Illustration 208. *Rowley-A-Go-Go.* 1996. *Bear.* 5in (13cm); golden tan distressed mohair and miniature type fur; plastic eyes; artificial suede paw pads; polyester fiberfill and stainless balls; fully jointed. Little jointed dog prepares the embroidery thread for bear to knit vest.

Masako Okada
Beary Mako
Aichi, Japan

Ten years ago I was visiting America and found a teddy bear at a garage sale. I was charmed with the bear, so I thought it would make me happy if I could make one too. My bears have long noses and look real and are usually made of brown mohair. I really enjoy bear conventions where I meet so many people. I love to receive letters from people who like my bears.

Began selling retail: 1993
Price range: $168 (11-½in/30 cm) -
$300 (15-½in/40cm)
Approximate annual production: 50-60
Approximate number of shows per year: 3-4

Illustration 209. Masako Okada.

Illustration 210. One of Masako's favorite realistic bear designs.

Miyoko Taniguchi
Miyoko's Bear
Mie-Ken, Japan

Except for very special cases, I do not make bears to sell. I never studied bear making. I believe making bears is more a form of art than a form of study. In other words, I feel if an individual does not possess some kind of talent in this area, even a great amount of study won't necessarily enable them to be able to become successful at this skill. I do teach a course twice a month at a Culture Center in Nagoya. To achieve the bear's facial expressions exactly as I imagine, I start with a paper pattern. My goal is to have people look at a bear and appreciate what I had in mind when I designed it.

Does not sell bears
Approximate annual production: 20-30
Approximate number of shows per year: 0

Illustration 211. Miyoko Taniguchi.

Illustration 212. *Ursus Arctos (large bear).* 1997. 24in (61cm); dark brown tipped mohair; gray glass eyes; light modeling paste is applied to a suede surface on paw pads to create a raised texture. Hard stuffing. Wood wool and Kapok stuffing; fully jointed; 10 sets of joints used throughout body to allow positioning of head, neck and ankles. Received first place at the 1997 JTBA's 5th Convention in Tokyo. Small Bears are 10in-14in (25cm-36cm).

Shizuko Tatejima
Chiba, Japan

Illustration 213.
Shizuko Tatejima.

I am a stickler for originality. The first time I saw a big bear in a shop window, I was spellbound. I felt that he was not just a stuffed toy. My bears are not just stuffed toys either. They are fully jointed with both long and short mohair coats. If I use short mohair, the bears are also dressed. When my collectors are happy, it gives me great happiness as well. Sometimes it is difficult to decide on a price, but the longer I sew the better I get at pricing and production.

Began selling retail: 1991
Price range: $87 (6in/15cm) -
$390 (18-½in/45cm)
Approximate annual production: 100
Approximate number of shows per year: 4

Illustration 214. *Forest.* 1995. 4in-9in (10cm-23cm); beige and brown sparse short and distressed mohair; glass eyes; cotton and stainless steel ball stuffing; jointed arms and legs, unjointed heads. Bears made for 1996 Tokyo Festival. Concept is "Protect Nature and Forests".

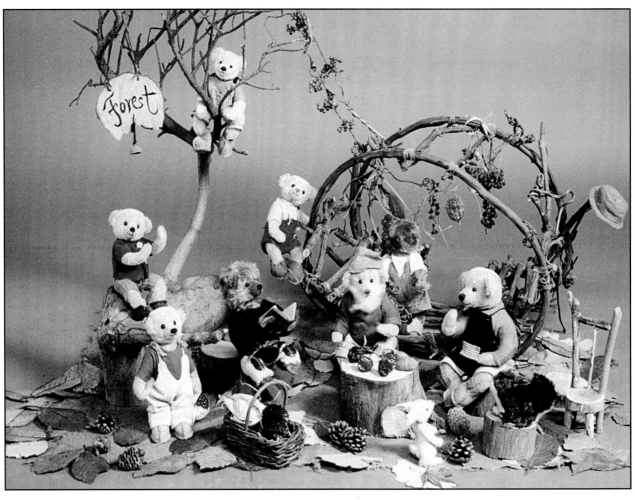

I started work as a bear artist after a long career in medical care. Once, while a nurse, I gave a little boy patient a teddy bear that I had made. It delighted him. And my prayers that he would get better were answered. This incident awakened a desire to become a professional bear artist. So, in 1994, I established Eriko Factory™ and began making bears as a career, not just a hobby. We have several staff members, including a teddy bear artist, planner, designer, manager and an assistant instructor. To my great pleasure, I have many clients, but my production is not sufficient to meet their demands. I hope to bring people together through teddy bears, transcending language and cultural differences. I am still happiest when I cuddle my teddy bears which gives me great peace of mind.

Began selling retail: 1994
Price range: $200 (11-½in/30 cm) -
$300 (16-½in/40cm)
Approximate annual production: 60
Approximate number of shows per year: 2

Illustration 215. Eriko Toichi.

Illustration 216. *American Dream Heroes.* 1996. 16in (41cm); rusty beige German mohair; glass eyes; ultrasuede paw pads; pellet and wadding stuffing; fully jointed. Uniform is white jersey with blue felt (team name, player's number). Handmade glove, shoes and belt of leather. Won Category Six 1997 TOBY Award. *Photograph by Yasuyoshi Ienaka.*

Illustration 217. (Left) *Lady Yukari.* 1996. 18in (46cm); pink German mohair; glass eyes; ultrasuede paw pads; pellet and wadding stuffing; fully jointed. *Lady Yukari"* won the Yellow Ribbon (third place) at Linda's 1997 Artist Bear Competition in San Diego, California. (Center and right) *Eriko and Hideaki.* 1996. *Girl* 17in (43cm); *Boy* 18in (46cm); gold German mohair; glass eyes; ultrasuede paw pads; pellet and wadding stuffing; fully jointed. *Hideaki and Eriko* won the Artist of the Year (category twelve) in British Bear Artist Awards 1997. *Photograph by Yasuyoshi Ienaka.*

Chizu Yoshida
Tokyo, Japan

Illustration 218. Chizu Yoshida.

I've learned that observing a lot of things, not only teddy bears, gives me so many ideas. This observation helps my originality with each new bear I make. All of my bears are different designs. They are quite small, but classic in style. Sometimes my friends and I get together and make bears in our homes.

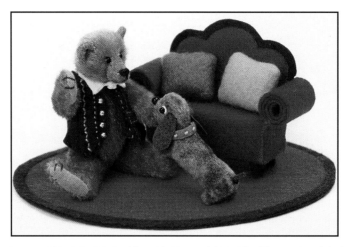

Illustration 219. *Together Always.* 1997. Bear 3in (8cm); brown miniature fur; glass black seed bead eyes; artificial suede paw pads; cotton and stainless steel pellets stuffing; fully jointed. Awarded the gold prize at the 5th Japan Teddy Bear Convention in 1997.

Began selling retail: 1995
Price range: $100 (2in/5cm) - $250 (4in/10cm)
Approximate annual production: 120
Approximate number of shows per year: 3-4

Mitsue Yoshida
Saucy Bear
Iwate, Japan

Illustration 220. Mitsue Yoshida.

I had been running a patchwork class and shop for 20 years. When I received a prize for a patchwork teddy bear, it was an opportunity to start making teddy bears. Many of my bears are boys and sharp-featured. Most are one-of-a-kind, but I do create limited editions (5 pieces) when ordered ahead. It is wonderful when a client chooses a bear which is also my favorite. I tend to create bears that show my personality and often make bears for the sheer pleasure of it, not for the sale of it.

Began selling retail: 1993
Price range: $140 (8in/20cm) - $780 (35in/90cm)
Approximate annual production: 100-150
Approximate number of shows per year: 4

Illustration 221. (Left to right). *Bear.* 1997. 28in (71cm); gray wavy British mohair; leather eyes; reversed mohair; polyester fiberfill and plastic pellets stuffing; fully jointed. *Together (Bear and Monkey).* 1997. Bear 16in (41cm) high; dark brown German mohair; glass eyes; mounted on wooden rockers. Won Golden George Award at Teddybär Total's 1997 Competition. *Elephant* 14in (36cm); *Bear.* 1997. 28in (71cm); black/gray tipped British mohair; leather eyes; reversed mohair paw pads; polyester fiberfill and plastic pellet stuffing; fully jointed.

When I was a small child, I made some teddy bears from felt and other fabric scraps. It was difficult to get mohair and jointing materials. I won a gold award in a Japan Teddy Bear Association in 1994, my very first exhibit. After I traveled to England and Germany where I visited a number of specialty teddy bear stores, I started to think about making teddy bears seriously. Prior to this I was a designer for knitted dresses and now I've combined this with teddy bear making. They are all hand sewn and wear hand-knitted dresses.

Began selling retail: 1994
Price range: $80 (2-¼in/6cm) - $780 (28in/70cm)
Approximate annual production: 150-200
Approximate number of shows per year: 3-4

Illustration 222. Maki Yoshizawa.

Illustration 223. *Strawberry Farm.* 1996. 15in and 22in (38cm and 56cm); antique rose kinky curly mohair; glass eyes; ultrasuede paw pads; polyester fiberfill stuffing; fully jointed. Hand-knitted one-piece apron, bonnet and strawberry motifs. Special award in Primera's competition.

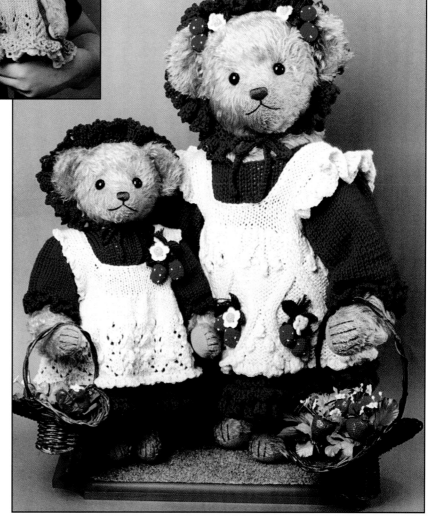

New Zealand Teddy Bear Artists

Robin Rive:

A view from down under.

New Zealand's British colonial heritage resulted in a great love of traditional English toys with teddy bears the number one choice. The number of bears sold is huge in ratio to our population. We have about 20 teddy bear clubs in our small country and about ten shows a year (some are combined with doll shows).

The average age of New Zealand teddy bear artists is from 40 - 45 with perhaps five percent making bears full-time. Serious part-time artists account for 15% and the remaining 80% make bears solely for their own pleasure and the satisfaction of belonging through clubs to a group of like-minded people.

Most artist bears here are mohair; there are some made which are synthetic and a very few from natural pure wool. More of our bears are undressed or minimally dressed rather than the alternative. Because bears are so popular, materials are easy to come by. What we frequently lack, unfortunately, is interaction with bear artists from other parts of the world.

Sandy Coombs
Sandy's Bears
Kimbolton, New Zealand

Jennifer Laing was my initial inspiration to make bears. I was fortunate to be in one of her classes. Since I already owned one of her creations, I knew what she had achieved and where bear making could lead you. One of my greatest achievements was being included in her book The *Complete Book of Teddy Bear Artists in Australia and New Zealand.* Presently I use four basic pattern designs with different fabrics which gives quite a variation. I then give the bears different accessories such as wings and balloons. This gives each bear its own character. I love improvising and making the accessories if I can. When turning body parts on my miniature bears, I use a thin drinking straw to help. This is inserted into the tiny body part and then I use the blunt end of a bamboo skewer to push against it.

Began selling retail: 1994
Price range: $175NZ (2-¾in/7cm) -
$195NZ (5in/13cm)
Approximate annual production: 50
Approximate number of shows per year: 1 major

Illustration 224. Sandy Coombs with examples of her endearing Fairies and several other precious miniature bears.

Joan Easton
Hazeley Bears
Hamilton, New Zealand

My husband Ivan was visiting a bear fair with me for the first time and wondered how quickly he could escape to play golf. When I expressed desire for a small Hermann teddy, he took out $20 from his wallet...thinking that would secure a sale. When he was told the bear was more than $200, he quickly advised me to make my own, because I had been making soft toys for years. So, he went to golf. I returned home and made *Wistful Walter*, my first bear. (Ivan later purchased that Hermann bear). The type of bears I create reflect my love of my original bear who was so loved that my mother constantly mended and re-pawed him. I always dress my bears in pure cotton or silk fabrics in an effort to create the type of attire my bear would have had in the 1940s. I haven't entered many competitions, but did so in the U.K. and won a best dressed bear in show award. I have also won two awards here in New Zealand. One of my favorite bear stories is about my doctor, a bear collector, who asked me to make a cross-eyed bear, called *Gladly*. Normally, I don't make "cute" bears, but managed to find two mismatched glass eyes and made the bear. The doctor explained to me that his favorite hymn as a boy was "Gladly Thy Cross I Bear" ...he thought it was about a cross-eyed bear! I sell my bears wholesale to a few top bear shops in the U.K., Singapore and Switzerland. I also make limited editions for Ian Pout, U.K. and for Tricia's Treasures, N.Z. And, by the way, my husband now is a dedicated arctophile.

Began selling retail: 1994
Price range: $90 (3in/8cm) -
$230 (9in/23cm)
Approximate annual production: 300
Approximate number of shows per year: 8

Illustration 225. Joan Easton.

Illustration 226. (Left to right). *Maude and Lily.* 1997. 5-½in (14cm); vintage rayon plush; pale rose (*Maude*), pale gold (*Lily*); black German glass eyes; wood wool and Orlon stuffing; fully jointed. *Photograph by Colin Coutie.*

Janis Harris
Almost South Pole
Auckland, New Zealand

I began by making dolls and teaching doll making. I continue to make both dolls and bears. I would like to make them in equal amounts, even though I know bears "breed" faster. My most popular bears are mid-sized; but I did have the occasion to make two bears that were the same size as me! The leg joints were the size of dinner plates! I've won many awards. One time I won both the Best Bear and Best Original Doll in the very same show. Most of the bears I make are of mohair, but I also use wool, Hessian, antique fabrics and, when I can get them, beautiful old mohair rugs.

Began selling retail: 1985
Price range: $95 (12in/31cm) - $800 (large bears)
Approximate annual production: 150-200
Approximate number of shows per year: 4

Illustration 227. Janis Harris.

Illustration 228. (Left). *Gordon.* 1995. 7in (18cm); tan mohair; black glass eyes; Orlex® stuffing; fully jointed. One-of-a-kind. (Right) *Berryman.* 1997. 15in (38cm); brown mohair; beige felt face; glass googlie-type eyes; open mouth; Orlex® stuffing; fully jointed. Inspired by Clifford Berryman's famous cartoon character. Signed by Clifford Berryman's grandson.

Heather Lyell
D'Lyell Bears
Auckland, New Zealand

In 1992 my husband and I opened our teddy bear shop "Bear Essentials." We retailed bears and I also ran bear making and design classes. We just sold the shop, so I plan to take it a little easier and design some new styles and exhibit in some European shows. In 1994, I organized an extremely successful charity bear auction for the prevention of child abuse. We raised $16,000 with only 42 bears. My two bears went for two of the highest three prices! I am thrilled to report that the German manufacturer, Hermann, just released one of my bears called *Edwin* at the Nurnberg show. This is the first time any Southern Hemisphere designer has had a bear accepted by a German company. *Edwin* also features a unique center joint, which I believe is a world first. Not only is *Edwin* a limited edition of 2000, but he is on the front cover of their catalogue for 1998/99. Also, Peter Fagan from the Scottish company Colour Box bought one of my bears from my "Old Girl Series" and he will be modeling *Aunt Mabel* in his fabulous resin series for the 1999 release.

Began selling retail: 1992
Price range: Naked Mohair $200-300
"Old Girl Series" $600-900 (20in/51cm)
Approximate annual production: 30
Approximate number of shows per year: 3

Illustration 229. Heather Lyell.

Illustration 230. *Aunt Lenore.* 1996. 20in (51cm) (sitting); gold German mohair; German black glass eyes; leather paw pads; flock stuffing; fully jointed; (wooden nut and bolt joints). *Photograph by Roy Watkins.*

134

Singaporean Teddy Bear Artists

Leonard G.
J.A. Bruins Design
Singapore

I just began making teddy bears and I am so proud to have already won the 1997 National Teddy Bear Artist Award organized by Sasha's and Co. here in Singapore. Sasha's is my main representative and I have exhibited in shows in Japan, at the Hugglets Fair, in Singapore and Kensington. I have found it very fulfilling to see my designs come to life, but it is difficult to find the extra time to experiment with new ideas.

Began selling retail: 1997
Price range: S$160 (9in/23cm) -
S$400 (20in/51cm)
Approximate annual production: 30
Approximate number of shows per year: 4

Illustration 231. Leonard Gotoking.

Li Lee-Kuang
Twinkle Bear
Singapore

Five years ago when I was in Perth (Australia) I happened to walk into a teddy bear shop for the first time in my life. I instantly fell in love with bears. I attended two workshops with Olivia Russel and Jennifer Laing after I told myself that I too could create such loveliness. My "trademark" feature is the big bow tied around my bears heads. Most of them are very feminine, in light shades, always fully dressed in a sweet-looking costume. Made primarily of dense and curly German mohair with suede paws, they all wear a "please-love-me" expression and come with matching accessories such as soft toys, pillow or little animal friends. I really enjoy meeting collectors since it is wonderful to personally get to know someone who appreciates my work!

Began selling retail: 1996
Price range: S$199 (12in/31cm)- S$420 (16in/41cm)
Approximate annual production: 50
Approximate number of shows per year: 3

Illustration 232. Li Lee Kuang with two of her appealing little girl bears *Lollie* (left) and *Kendra* (right). *Photograph by Yoke Wee.*

Evelyn Lee
Jus' Teddy
Singapore

Since I am a clown collector, the first bear that caught my attention was a clown bear by Karla Mahanna. By the time I decided to purchase it, it was too late. The same thing happened two or three more times, so I finally bought a kit and decided to give it a try myself. My first bear, an antique 8in (20cm) bear looked like a monkey! I tried again, till I got it right. I still prefer to make antique looking bears, but do make more contem-porary looking ones as well. I have won a few awards already. I was overall winner of the 1997 National Teddy Bear Artist of the Year Award and also received a first prize for dressed miniatures and was first runner up for miniature undressed. I also was second runner up in a competition in Australia in 1997. All my bears stand on a heart shaped base which is painted to match the color of the bear itself.

Began selling retail: 1997
Price range: S$180 (1in/3cm) - S$480 (4in/10cm)
Approximate annual production: 30
Approximate number of shows per year: 2-3

Illustration 233. Evelyn Lee.

Illustration 234. *Let's Dance Bella.* (Left) *Bella.* 1997. 2-½in (6cm); light beige upholstery fabric; glass bead eyes; light beige ultrasuede paw pads; polyester fiberfill stuffing; fully jointed. (Flexi arms®). (Right) *The Beast* 3in (8cm); brown with dark brown tipped upholstery fabric; glass bead eyes; brown ultrasuede paw pads; polyester fiberfill stuffing; fully jointed (Flexi arms®). Props at the back, hand-painted with antique finishes. One-of-a-kind overall winner "1997 National Teddy Bear Artists of the Year Award" in Singapore.

136

Mark Rodrigues
Marko's Bears
Singapore

Most people are quite surprised to learn that I do not collect teddy bears, although I still have my childhood teddy with me, a Chiltern Hugmee with a plastic nose which was given to me when I was born in 1961. I create bears with a masculine appearance with realistic looking air-brushed faces, swept back ears, glazed noses/mouths, plump bodies and stocky limbs. Though inspired by wild bears I am very much a traditionalist and love the charm of antique bears. That is why my bears have a very teddy bear look about them and many of my creations have felt pads and embroidered claws. My wife, Germaine, helps me trace, cut out and sew up all the pieces. She is a wonderful perfectionist and the only other person I trust to help me with my bears. My bears have brought me some recognition. In August 1995 I was awarded first prize in original design in a contest organized by the teddy bear shop Paw Marks. Then, a week later I was voted Teddy Bear Artist of the Year (1996) at Asia's First Teddy Bear Picnic. Through Sasha's & Company I have started exhibiting my bears including the first exhibit/sale of works by local artists at Bears of Singapore Exhibition. I use nut and bolt joints and leave them a little loose, a characteristic of many of the antique bears I've come across. If the joints are too stiff, you run the risk of ripping the fabric at the joints some point in the future. If I do not overly tighten the joints, they do not work loose and it saves the fabric at the points of most friction. Since I usually have a pretty good idea of what my bears are going to look like prior to sewing up the bear's head, I shave off the hair for a clean shaven muzzle look. It makes it a whole lot easier to sew the "u"-shape of the muzzle. One way to I've gotten a lot of good feedback is talking with people from the non-teddy bear world . My friends and other people who have little to do with teddy bears have given me some of the best advice!

Began selling retail: 1996
Price range: $240 (13in/33cm) - $440 (18in/46cm)
Approximate annual production: 40
Approximate number of shows per year: 2-3

Illustration 235. Pam Hebbs and Mark Rodrigues at Asia's First Teddy Bear's Picnic at Fort Canning Park on August 18, 1996, where Mark was awarded the title "Teddy Bear Artist of the Year."

Illustration 236. (Front) *Julius.* 1997. 16in (41cm); golden tan distressed mohair; shoe-button eyes; felt paw pads; polyester fiberfill stuffing; fully jointed (fiberboard discs/locknuts). Air brushed detailing to face and pads, growler and handmade collar, glazed nose. One-of-a-kind. (Back) *Kodi.* 1997. 18in (46cm); brown with black tipped mohair (straight); shoe-button eyes; felt paw pads; polyester fiberfill stuffing; fully jointed (fiberboard discs/locknuts). Airbrushed detailing to face, glazed nose, growler. One-of-a-kind. Category winner for bears 13in (33cm) and over, undressed 1997 National Teddy Bear Artist Award Singapore.

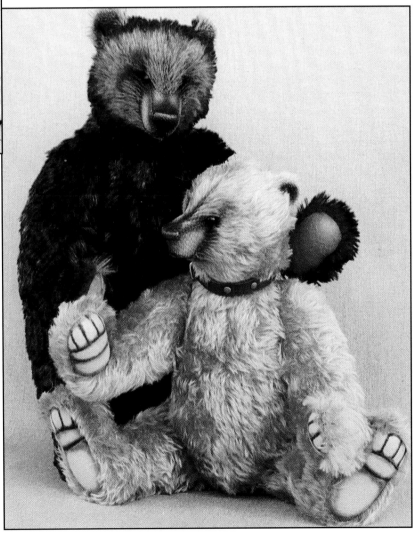

Fabian Song
Fabian's Teddy
Singapore

My chubby-cheeked bears are both male and female. These rich brown bears are accessorized with little details and dressed according to their characteristics. Occasionally, the bears are accompanied by little animals like puppies. One of my more popular designs is a creation of a little panda named *Xiao Le*, which means "Little Happiness" in English. I have accom-plished several achievements in the world of teddy bears. I am most pleased to have emerged a winner for the Medium Sized dressed Bear category in the First Singapore Teddy Bear Competition. I've also done bear making demonstrations a the Singapore National Heritage Museum and on board the Star Cruise Luxury Liner. Furthermore, I have been interviewed on the "Good Morning Singapore" program and also given demonstrations on a Singapore local TV station.

Began selling retail: 1996
Price range: $100 (8in/20cm) - $350 (22in/56cm)
Approximate annual production: 100
Approximate number of shows per year: 5

Illustration 237. Fabian Song.

Illustration 238. *Chu Ba Wang.* 1997. 23in (58cm); ivory straight mohair; glass eyes; ultrasuede paw pads; polyester fiberfill and pellet stuffing; fully jointed (nuts and bolts). Silk, soft leather, gold sheet metal and PVC leather used to make clothes. Inspired by Chu Ba Wang, a character in a Chinese Cultural dance drama.

Imeldo Teo
Bear Bottoms
Singapore

My friends think that my bears look like my sister, my sister looks like me, which means that I probably unconsciously model my bears after myself. Actually, all my bears come with a little heart on the left sides of their bottoms, which is why they are called Bear Bottoms. There is no one type of bear that I make most often to sell. My bears tend to carry the same characteristics and my ideas are almost always inspirational. I do, however, prefer to make more feminine bears as these are the bears which seem to be more popular. Being a little greedy myself, I do have a habit of drawing my ideas from food. I had the privilege of winning two categories in the first Singapore Teddy Bear Artists awards in 1996. I am also pleased to have made two bears for auction, one was in aid of a local charity for disabled children, the other for wild life conservation in conjunction with the Singapore Zoo. I was also invited as one of the only three Singaporean Artists to make a one-of-a-kind teddy bear display of a local theme to be displayed at the Huis Ten Bosch Teddy Bear Kingdom in Japan and appeared several times on local television to demonstrate the art of bear making.

Began selling retail: 1997
Price range: $80 (2in/5cm) - $300 (16in/41cm)
Approximate annual production: 30
Approximate number of shows per year: 2-3

Illustration 239. Imeldo Teo.

Illustration 240. *Nonya and Baba.* 1997. 18in (46cm); brown and beige German mohair; glass eyes; ultrasuede paw pads; polyester fiberfill and pellet stuffing; fully jointed (nuts and bolts). Female: traditional embroidery on cotton-batik skirt. Male: satin silk Chinese shirt, batik sarong. Chinese/Peranakan traditional couple. One-of-a-kind. Made especially for the Huis Ten Bosch Teddy Bear Kingdom, Museum, Nagasaki, Japan.

Teddy Bear Artists Index

147 Artists

AUSTRALIAN TEDDY BEAR ARTISTS

Rae Hargrave
Teddies To Love
P.O. Box 193
Mt. Evelyn, Vic., 3796
Australia

Heather Helbig
Furry Tails
27 First Street
Clayton 3168
Victoria, Australia

Rebecca Hurley
Nature Teds
P.O. Box 513
Roxy Downs SA, 5725
Australia

David and Sharyn Hutchins
Brookside Bears
P.O. Box 571 Rosny Park
Tasmania 7018
Australia

Jennifer Laing
Totally Bear
P.O. Box 580
Avalon Beach
NSW 2107
Australia

Jo-anne Noorman
Jo's Tiny Teddy's
8 Violet Street
Frankston, Victoria 3199
Australia

Petra Wasse
The Old Bear Company
P.O. Box 302
Kalamunda 6076
Western Australia

Jacki Williams
Bare-Belly Bears
10 Erica Crescent
Heathmont 3135
Melbourne, Australia

AUSTRIAN TEDDY BEAR ARTIST

Renate Hanisch
Bears From No. 27
Larochegasse 27
A-1130 Vienna
Austria

BELGIAN TEDDY BEAR ARTIST

Helga Torfs
Humpy Dumpy Bears
Veldstraat 72
2450 Meerhout
Belgium

BRITISH TEDDY BEAR ARTISTS

Sarah Bird and Alexander Longhi
84 High Street
Pershore
Worcs WR10 IDU
ENGLAND

Deb Canham
Deb Canham Artist
Designs, Inc.
115 N. Tamiami Trail, Suite #8
Nokomis, FL 34275

Paula Cawley
Paula Bears
Stoke on Trent
United Kingdom

Karin Conradi
Conradi Creations
21 Telford Ave.,
Streatham Hill
London SW2 4XL
United Kingdom

Linda Edwards
Little Treasures
7 Crees Lane
Farndon Road
Newark, Notts
NG24 4TJ
United Kingdom

Jo Greeno
9, Cranley Close
Guildford
Surrey, GU1 2JN England

Claudia Hawkins
The Claudia Collection
Pound House
Horse Fair Street
Charlton Kings
Cheltenham
Gloucestershire GL53 8JF
ENGLAND

Pam Howells
Pamela Ann Designs
12 West Street
Crowland

Peterborough,
PE6 OED United Kingdom

Elaine Lonsdale
Companion Bears
6 Claremont Drive
Timperley
Altrincham
Cheshire
WA14 5ND England

Jayne Loughland
Mystic Bears
4, Woodland Park
Colwyn Bay
Conwy LL29 7DS
United Kingdom

Nicola Perkins
Nicola Perkins Miniature
Bears
2 The Spinney
Madeley Heath
Nr. Crewe
Cheshire, CW3 9TB
United Kingdom

Christine Pike
Green Lizard Marketing
9 New Road,
Lake, Isle of Wight,
PO Box 36 9JN
United Kingdom

Kathryn Riley
Kathryn M. Riley
Wirral
United Kingdom

Sue Schoen
Bocs Teganau
9 Radnor Drive
Ton-teg, Mid-Glamorgan
South Wales CF38 1LA
United Kingdom

Kay Steet
Kaysbears
93 Stinglewell Road
Gravesend
Kent DA11 7PU
ENGLAND

Stacey Lee Terry
Bo Bear Designs
1 Castle Street
Buckingham,
BUCKS MK18 1BS
ENGLAND

Frank Webster
Charnwood Bears
c/o 4, Ashby Square
Loughborough,
Leicestershire
LE11 OAA
United Kingdom

CANADIAN TEDDY BEAR ARTISTS

Edie Barlishen
Bears By Edie
42 Greer Crescent
St. Albert, Alberta, T8N 1T8
CANADA

Barbara Buehl
Buehl Bears
1380 Kingsview Road
Duncan, British Columbia
V9L 5P1
CANADA

Barb Butcher
Heartspun Teddy Bears
502-6801-59 Avenue
Red Deer, Alberta T4P 1B3
CANADA

Lorraine Chien
1233 Fieldstone Circle
Pickering, Ontario
CANADA

Debby Hodgson
Homemade Hugs
104 Denman Dr.
Qualicum Beach
B.C. V9K 1R7
CANADA

Joan Links
Bear Links & Co.
666 Spadina Ave. Apt. 512
Toronto, Ontario, M53 248
CANADA

Susan and Mark McKay
Bears of the Abbey
1103 Queens Avenue
Oakville, Ontario
L6H 4K9
CANADA

Wendy McTavish
McTavish Teddies
3 Union St
Erin, Ontario NOB ITO
CANADA

**Pauline Merlin and
Colleen (Merlin) McLaughlin**
Bear Magic Canada
621 Chiron Crescent
Pickering, Ontario LIV 4T6
CANADA

Brenda J. Power
Brenda Power Miniature
Bear Artist
802 Maley Street
Kemptville, Ontario
KOG 1JO
CANADA

John Renpenning
Johnny Bears
1904-20 Ave. N.W.
Calgary
Alberta T2 M 1H5
CANADA

Ingrid Norgaard Schmid
Bears "N" Company
59 Melinda Crt.
Barrie, Ontario
L4N 5T7
CANADA

Joan C. Stevenson
Wildlife Originals
RR#1 Site 16 C30
Gabriola Island, British
Columbia
90-VOR 1XO
CANADA

DANISH TEDDY BEAR ARTIST

Maj-Britt Lyngby
Majse Bear
Skibstrupvej 20
3140 Alsgarde
Denmark

DUTCH TEDDY BEAR ARTISTS

Tim Bos
Bos Beren
2E Weteringdwarsstraat 34 I
1017 SW Amsterdam
Netherlands

Lyda Rÿs-Gertenbach
Lyda's Bear
De Zevenhoeven 64
1963 SH Heemskerk
Netherlands

Marjan Jorritsma-de Graaf
Tonni Bears
De Veldkamp 1
9461 PA Gieten
Netherlands

Tineke Oostveen
Atelier "Bear In Mind"
Kortedijk 20
3134 HB Vlaardingen
Netherlands

Judith Schnog
OURS
Heelmeestersdreef 338
7328 KD Apeldoorn
Netherlands

Paula Tinga
Paula Tinga Originals
Loosduinsekade 356
2571 CE Den Haag
Netherlands

Richard van Aalst
Richland Bears
Hooiersweide 85
3437 DS Nieuwegein
Netherlands

Sylvia van Otterloo
Sylbears
3224 VK Hellevoetsluis
Netherlands

Gerda van't Veer
PoeBé Miniatures
Dissel 28
6852 DR Huissen
Netherlands

FRENCH TEDDY BEAR ARTISTS

Hélène Bastien
Hélène Ours
Perrusson
France

Anne-Marie La Marca
La Marca Anne-Marie
5 Rue De La Tour
13001 Marseille
France

Suzan Tantlinger
56360 Sauzon Belle-Ile-En-
Mer France
Fransoise Bardoulat
1 Square D'Aurergne
91300 Massy
France

Laurence Veron
25 rue Oudry
75013 Paris
France

GERMAN TEDDY BEAR ARTISTS

Birgit Diedrich-Drobny
Bärfidel
Ostendstr. 82
74193 Schwaigern
Germany

Susanne Grosser
Ursa Minor
Rothmundstr. 6
80337 Müenchen
Germany

Christiane Kaufmann
Teddy-Activ
Finkenweg 1
65597 Hünfelden-Ohren
Germany

Ingeborg Taivassalo-Lutz
Teddybären-Atelier
Am Aten Markt 10
79539 Lörrach
Germany

Werner Pyschny
Bear By Bear
Schneiderstr. 53
44229 Dortmund
Germany

Annette Rauch
Neuhawser Strasse 42
98701 Grossbreitenbach
Germany

Marie Robischon
Robin der Bär
14 Lassbergstrasse
79117 Freiberg
Germany

Kerstin Schibor
Schibor-Teddy
Berchenstr. 31
78532 Tuttlingen
Germany

Gaby Schlotz
Spielzeug & Design
Im Aichenbachhof 3
73655 Plüderhausen
Germany

Bettina & Fredy Springweiler
FBS-BÄR
Schlotheimer Str. 5
38442 Wolfsburg
Germany

Dagmar Strunk
Bärenhöhle Der Teddyladen
Zehntfeld 62
44575 Castop Rau
Germany

Claudia Wagner
Weini-Bären
LahnstraBe 4
65479 Raunheim
Germany

JAPANESE TEDDY BEAR ARTISTS

Miyuki Fukushima
Honobono Bears
6-7-6-3C Honcho
Nakano-Ku
Tokyo 164
Japan

Momi Iwabuchi
5-9-11-205 Honcho
Funabashi-city
Chiba 273, 0005
Japan

Ikuyo Kasuya
Bruin Ikuyo Kasuya
4-14-5 Yoga Setagaya
Tokyo 158-0097
Japan

Emiko Kitagawa
Tokyo
Japan

Yayoi Matsumae
Huggy Bears
2-7-101, 488 Sugeta-cho
Kanagawa-Ku
Yokohama 221,-0864
Japan

Fumiko Nose
F's F (Fumiko's Factory)
4-2-40-514 Kushiro
Kawanishi
Hyogo 666
Japan

Masako Okada
Beary Mako
Room #202, Dai2-SS-mansion
Nishinomori-Oeshimo, Kanie-town
Ama-district, Aichi-prefecture
497-0052 Japan

Michi Takahashi
Fairy Chuckle®
Kanagawa
Japan

Miyoko Taniguchi
Miyoko's Bear
Urban KEN 1-C,
406 2-chome Sakae-machi
Tsu-shi Mie-Ken 514
Japan

Shizuko Tatejima
Shi's Bear
1-30-2 Yachiyodai-higashi
Yachiyo-shi
Chiba-Ken 276,
Japan

Eriko Toichi
Eriko Factory
4-9-17-502
Kikawa-Higashi
Yodogawa-Ku
Osaka-shi
532 Japan

Chizu Yoshida
#808, 1-15-2 Ebisu-nishi
Shibuya-Ku
Tokyo 150 Japan

Mitsue Yoshida
Saucy Bear
55-77 Ueda Higashi
Kuroishino
Morioka IWATE 020-01
Japan

Terumi Yoshikawa
Biscuit Entertainment
Corporation - Rose Bear®
Tokyo
Japan

Maki Yoshizawa
Maki & Bears
#208, 2-10-5 Kyonancho
Musashino 180
Japan

NEW ZEALAND TEDDY BEAR ARTISTS

Sandy Coombs
Sandy's Bears
"Ailsa", RD54
Kimbolton, New Zealand

Joan Easton
Hayeley Bears
48B Beerescourt Road
Hamilton, New Zealand

Janis Harris
Almost South Pole Bears
23 Pohutukawa Ave.
Howick, Auckland, New
Zealand

Heather Lyell
D'Lyell Bears
P.O. Box 10178, Dominion
Road,
Auckland, New Zealand

SINGAPORE TEDDY BEAR ARTISTS

Leonard G.
J.A. Bruins Designs
c/o Sasha's & Company
3 Seah Street #01-03,
Singapore 188379

Li Lee Kuang
Twinkle Bear
32 Dover Rise
Singapore 138686

Evelyn Lee
Jus' Teddy
Block 319
Serangoon Ave. 2
#03-346
Singapore 550319

Mark Rodrigues
Markos Bears
558 Pasir R1S
ST. 51 #13-303
Singapore, 510558

Fabian Song
Fabian's Song
605B MacPherson Road
#08-14, Chimae Industrial
Complex
SINGAPORE 368241

Imelda Teo
Bear Bottoms
Block 28 #10-71
Jalan Klinik
Singapore 160028

ABOUT the AUTHOR

Linda Mullins was born and raised in England. She emigrated to America in 1969. She vividly remembers the comfort and security she received from her first teddy bear as a child.

Her lifelong love affair with the teddy bear never ended. Her present collection of more than 2000 bears began in earnest when her husband, Wally, gave her an antique teddy bear as a gift. That hobby of love escalated to a full-time profession and today Linda Mullins' knowledge and expertise are in demand throughout the United States, Europe and Japan.

A Southern California (Carlsbad, CA) resident, the San Diego and Los Angeles areas benefit from her extensive travels and interest with Linda's San Diego Teddy Bear, Doll & Antique Toy Show and Sale. She has now produced 39 of these popular two-day shows, featuring antique, collectible and artist Teddy Bears, Dolls and Toys by Linda and other dealers and celebrities from around the world.

The semi-annual show, is now in its second decade, and draws more than 3,000 people each time. With more than 200 dealers participating, the show is known for both the quality of bears and toys displayed, as well as for the charitable donations made locally to San Diego's Children's Hospital and internationally to Good Bears of the World.

In addition to collecting, speaking, educating and traveling, Linda writes books and articles on her favorite subject, teddy bears, their past, present and future. To date she has written 13 books on the subject and more are on the horizon.

She has been seen on the Q.V.C. network as national television spokesperson for a well-known soft toy manufacturer. Her personal appearances continue to grow and expand. She has been honored at the Disneyland and Walt Disney World®'s Teddy Bear Conventions, in this country. Internationally Linda has been an integral participant at Glenn and Irene Jackman's "British Teddy Bear Festival," the Teddybär Total in Germany, Rob and Inge Kulter's "Amerongen Bear Festival" in Holland, and also the Japan Teddy Bear Association Convention.

Among her hundreds of exceptional, antique and highly collectible bears are her favorite early Steiff, Bing and Schuco creations. She is honored to be working with the prestigious company, Little Gem Teddy Bears in projects to reproduce some of her rare early bears in miniature.

After an all-out effort coordinating a charitable auction of international artist's bears designed to raise funds for Kobe, Japan's earthquake victims, Linda Mullins became instrumental in shaping Huis Ten Bosch's Teddy Bear Kingdom. She is a supervisor and honorary director of the museum. The Teddy Bear Shop is named after her and one of the museums most popular exhibits is the reproduction of one of her teddy bear display rooms replicated from her residence in Carlsbad, California. This elegant museum, built as part of a beautiful European-style resort near Nagasaki, Japan is just one more step in Linda Mullins's lifelong goal to elevate the teddy bear to its rightful position as ambassador of world love and peace.